The Sweet Breath of Life

Also by Ntozake Shange

If I Can Cook/You Know God Can

Sassafrass, Cypress & Indigo

Liliane: Resurrection of the Daughter

Love Space Demands: A Continuing Saga

Betsy Brown

For Colored Girls Who've Considered Suicide When the Rainbow Is Enuf

Also by Frank Stewart

Sweet Swing Blues: On the Road a Year with Wynton Marsalis and His Septet

Smokestack Lightning

Romare Bearden: Photographs by Frank Stewart

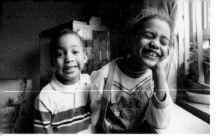
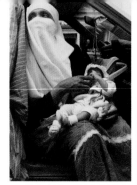
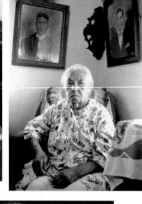
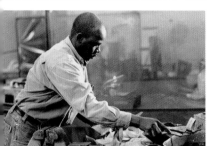
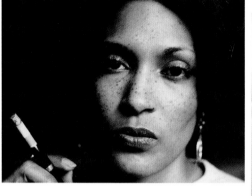
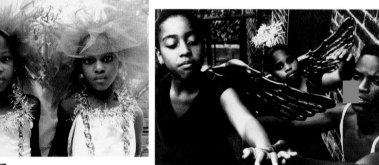
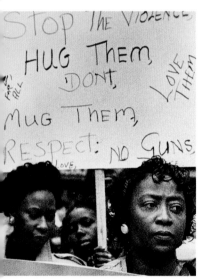
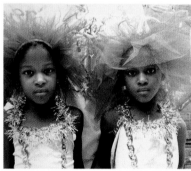
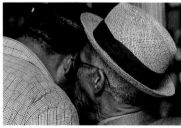
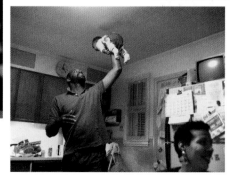
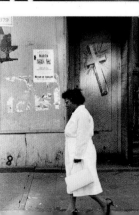

STOP THE VIOLENCE
HUG THEM,
DON'T
LOVE
THEM
MUG THEM,
RESPECT: NO GUNS,
LOVE

The Sweet Breath of Life

A Poetic Narrative of the African-American Family

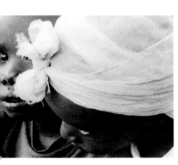

Poems by Ntozake Shange

Photos Edited by Frank Stewart

Photographs by Kamoinge Inc.

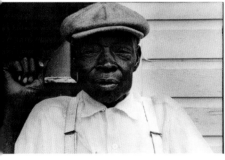

ATRIA BOOKS • New York London Toronto Sydney

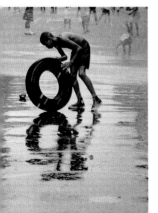

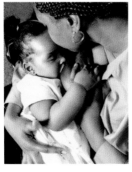

ATRIA BOOKS

1230 Avenue of the Americas
New York, NY 10020

ISBN 0-7434-7897-5

First Atria Books hardcover printing October 2004

10 9 8 7 6 5 4 3 2 1

ATRIA BOOKS is a trademark of Simon & Schuster, Inc.

Designed by Dana Sloan

The list of illustrations appears on pages 173–74

Manufactured in China

For information regarding special discounts for bulk purchases,
please contact Simon & Schuster Special Sales at 1-800-456-6798
or business@simonandschuster.com

with great admiration and love

for these three women who let me know

in no uncertain terms who and what i come from:

to my grandmother, viola benzena murray owens

to my great aunt, effie owens josey

and to my great aunt, mary owens

i lived long enough to be held by you all.

love, ntozake

This book is dedicated to all the black photographers
who have gone before us and on whose shoulders we now stand.

Acknowledgments

Herb Robinson,
for scanning and retouching numerous photographs.

Eric T. Kunsman,
coordinator of photography/assistant professor,
Mercer County Community College, West Wendsor, New Jersey,
for scanning all photographs by Lou Draper.

Introduction

The Sweet Flypaper of Life, a book by Roy DeCarava and Langston Hughes, first published in 1955, was pivotal in my growth to becoming a photographer. I thought this book was the best and most honest poem about the urban black that I had seen to date, and it became my quest to someday further the discussion.

In the late sixties, I came to New York to study photography with Roy DeCarava, and during that time, I also became familiar with some members of the Kamoinge Workshop. The group was formed in 1963 with Roy as the first director. In addition to studying with Roy, I got pointers from Lou Draper and Danny Dawson. Sometimes a few encouraging words of technical advice can subtract years off learning time.

The work that I had seen coming from the Kamoinge Workshop—now known as Kamoinge Inc.—best represented what I thought was the logical progression from *The Sweet Flypaper of Life.* I set out to become a member, but it wasn't until the late eighties that I received my opportunity.

Kamoinge exists as a forum for African-American photographers to view and critique work in an honest and understanding environment, and to nurture and challenge each other in order to attain the highest level of creativity. The name comes

from the Kikuyu language of Kenya, and is translated as "a group of people acting together." The group's aim is to seek out the truth inherent in our cultural roots, and to create and communicate these truths with insight and integrity.

In the sixties the Kamoinge workshop stopped meeting on a regular basis, but came together from time to time for group shows. In the early nineties Anthony Barboza suggested that the group begin meeting again and admit new members. John Pinderhughes and myself were the first to apply and be accepted. Since the objective of the name and the group was to work together, the logical step to take was a group-effort book. It was agreed that we do the book in the same vane as *Sweet Flypaper*.

I first met Ntozake at the time her choreopoem *For Colored Girls Who Have Considered Suicide When the Rainbow Is Enuf* was premiering on Broadway. I thought her poetry was revolutionary and knew she would be a great artist with which to collaborate on a book project. It wasn't until twenty-four years later that *Sweet Breath* became a reality and we were able to match her poetry with visual images.

It is my hope that *The Sweet Breath of Life* not only furthers the discussion begun by DeCarava and Hughes but inspires more dialogue.

—*Frank Stewart*

The Sweet Breath of Life

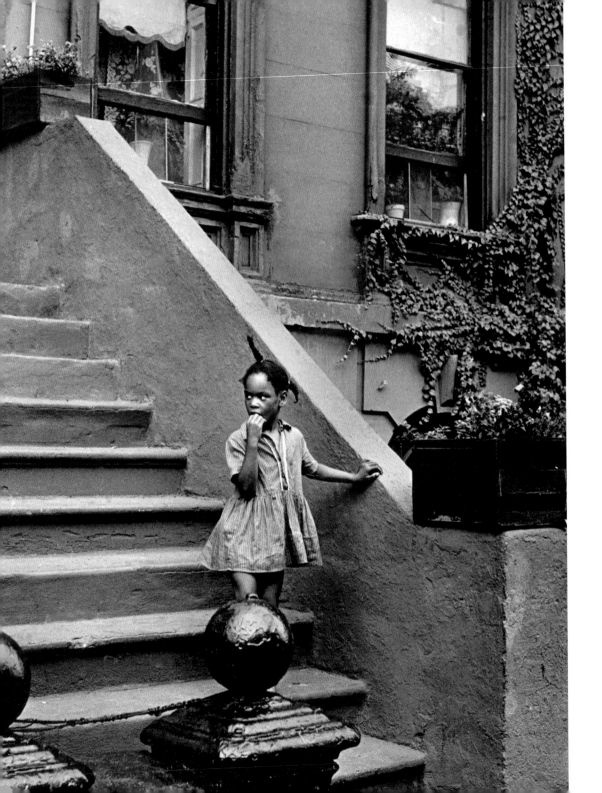

grand lil girl in all her glory

grand ol' houses that have seen better days

but never anyone like me / why my braid

is stickin' in the air like my grandma's & my

mama's when they were my age

only thing is they didn't think like i do

i think all the time 'bout what's gonna become

of my i gotta mighty fine dress on & it may not

be ironed but i like it jus' the same / e'm

thinkin' out here on the porch too much noise

in the house / a girl needs quiet to get to herself

my made self decorated with my braids / antenna

takin' in the sights & sounds of my today /

lookin' for signs of my tomorrow / but right now

i'm gonna suck my fingers & wait for the

visions / a girl in my position gotta have visions

& what i see right now is a plenty / my dreams

ivies up the walls of the grand ol' house / rushin'

out the corner of my eyes / do you see

somethin' out there for me?

a bit of the Lord will take you thru

light barely brushes their pictures / but the hope

in the photographs makes light magnificent

the memories flow on their own / or from the glistenin'

trumpet / the smile of the bride / the recruit

before danger & sons a plenty to carry on the family

names / what alarms me & causes heart palpitations

is the tear in "bless this house," how can we

do that with half the music missin' / how can we

celebrate our relatives / our family / if the blessing

from the Lord is carried on with so many notes &

verses missin' / perhaps the Lord will unnerstan' /

we got the piano to sing praises to his name /

we got the piano to get a lil bit closer

to God / gabriel's trumpet is testimony to that / our

children will carry on Lord with just half of yr

praises touchin' their hearts.

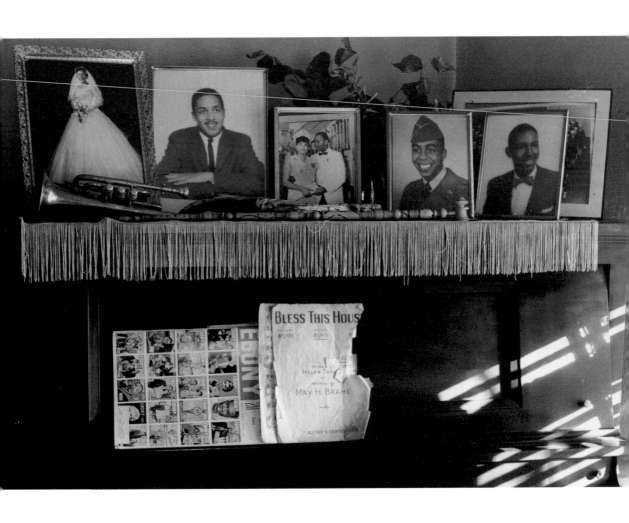

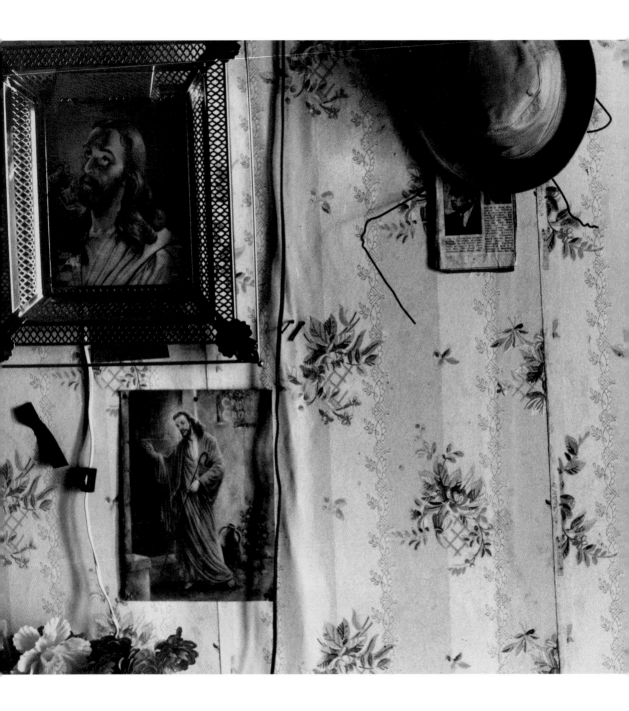

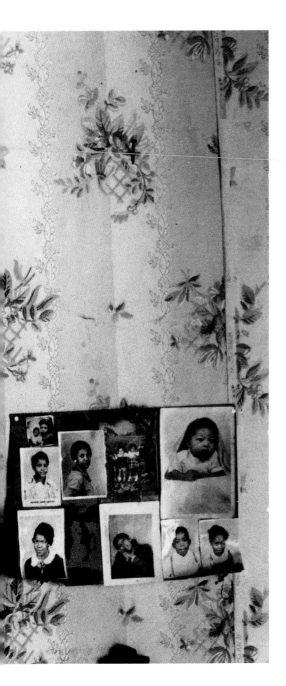

only so much i can do

don't he look peaceful / don't he look
humble in the robes of a simple man/ but
why he ain't lookin' at my children / steada
way off in the opposite direction / i'ma have
to do somethin bout that / the Lord lookin way'
from my brood / maybe what i'll do is move
things a round some / so long as i don't have to
move my straw hat

Lord, I'm
blossomin

aint this fine / aint this wonderful

my baby and i neath the thunderin sky

strangers all the time wantin to touch my tummy /

for they good luck / but not this time angel /

this is for us / the same waters that cradled noah's

arc are cleansin us & leaving us without shame /

i believe em now / my body is beautiful & so

are you / my pum'kin & my chile

look at the puddles that i skip thru / the

gleaming water on our skin / i'm havin such a good time /

naked and wet wit the skies for a cover and the rains for

a night shirt / did you ever think of that / my sugah that

we are clad in the tears on the heavens in the full of the day

& nobodies gonna say we wrong / we jus free the way a woman

aint 'magined to be / i'm sharin this gift with you / oh beloved chile of

mine / we almos ready for yr birthin / almos ready for you to

present ya self / who you gon be? huh / after all you done

bathed in the holy waters without no preacher with only

three lil ol' drops / pum'kin we gotta sky full of blessings

rainin / down on us & all we had was the courage

to reveal our naked selves to the horizon & her wonders /

& what's she do / she decorated us / o say our skins dark as night

in the midst of the day she lent us her jewels of gentle defiance

not strangers touchin us for good luck / she protectin us

we the sacred now? / i'm tellin ya / & we aint leavin this roof

where we dancin with the rain / til the sun come out or night falls

lettin us sleep and we don't have to tell our secrets

dancin naked in the rain in the full of the day /

what no respectable lady can

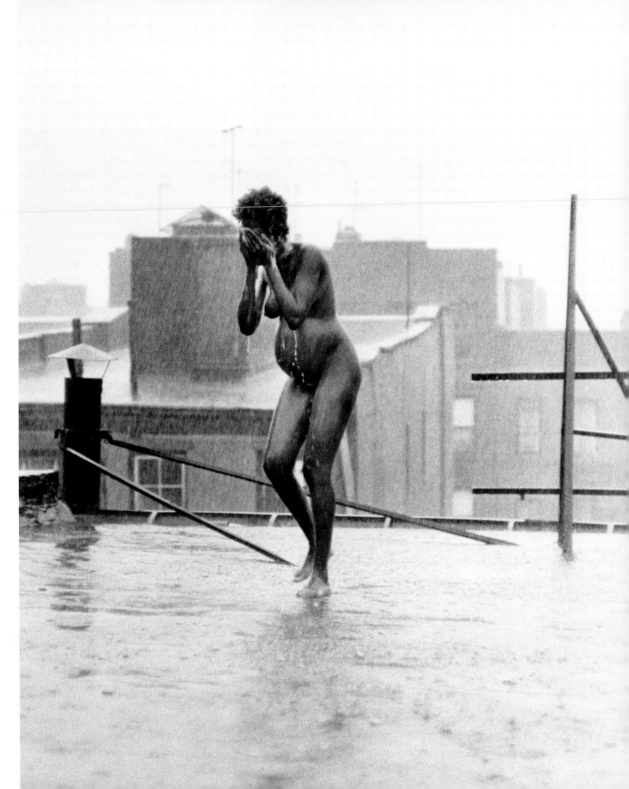

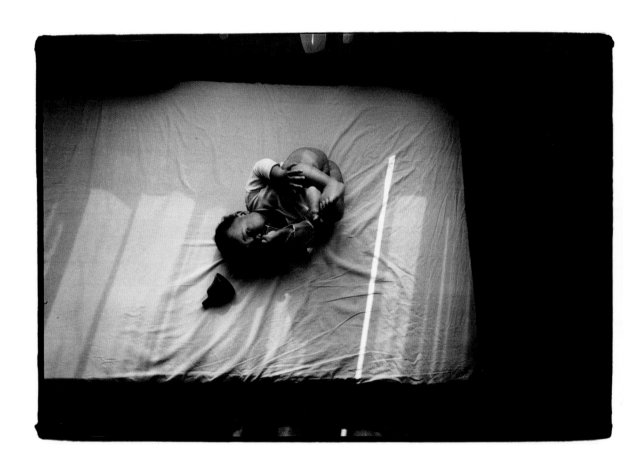

i've got the day all to myself and

a storm is surprising me in my nakedness

no matter. I'm awash with god &

the roof is not as close as I can get

no blushin here there's a simple

silhouette of the life within me

that rivals any lavender sunrise

come get naked with me and we'll

let life drip over us like so much

honey tupelo honey fresh from harlem

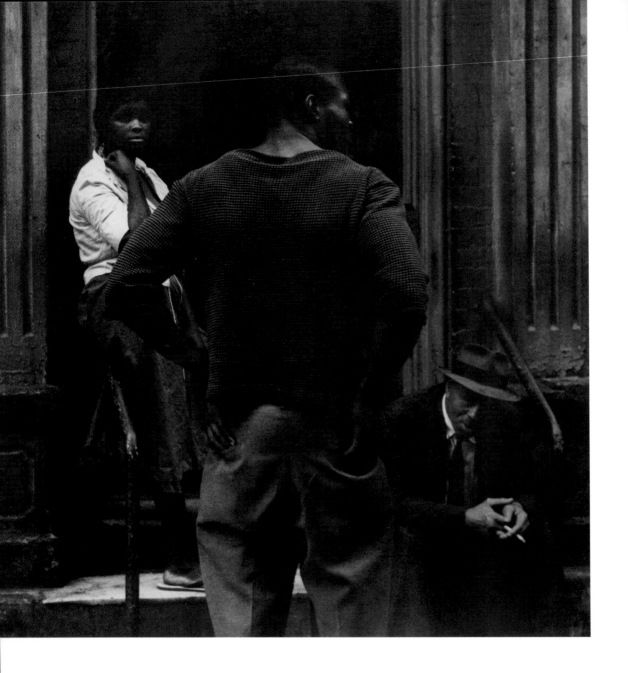

family restin in the city

jerome, get up out that chair &
let me & yr baby sit down, jo-jo'
whatcha lookin at / yall know bettah
than to let that chile / hang off the
rail like that / sometimes i don't know
what i'm gon' do wit yall / jo-jo what's
goin on down the street aint no
concern of yrs / jerome what got yr eyes
all squinted up like that? / whatever it is
my love will make it go on away / if you
jus' talk to me / don't nobody talk to me
'spect me to read yr minds / i ain't got
that kinda power / all i can do is jus' love
ya / all i know is how to love ya / will
somebody get that baby off the railin / or is
the killin down the street gon' do
us in too?

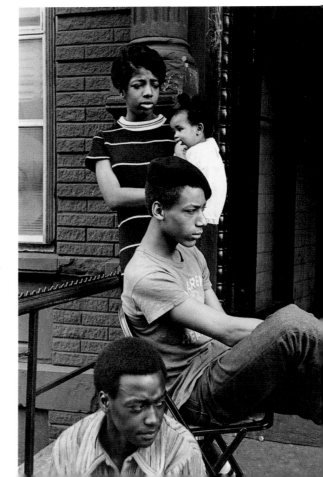

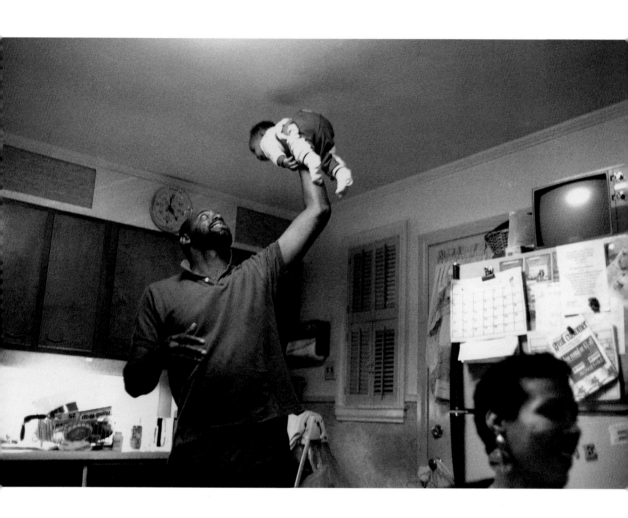

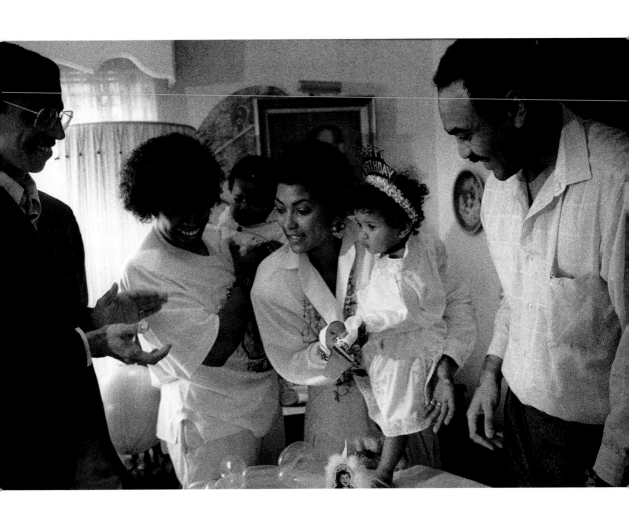

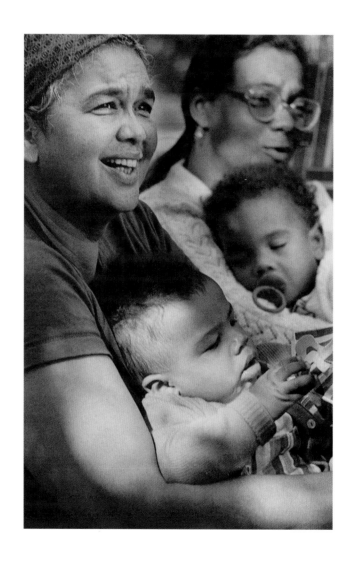

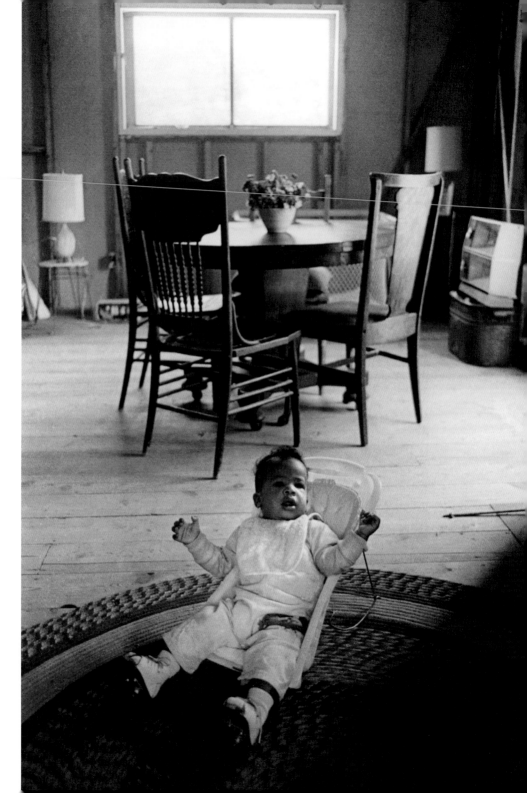

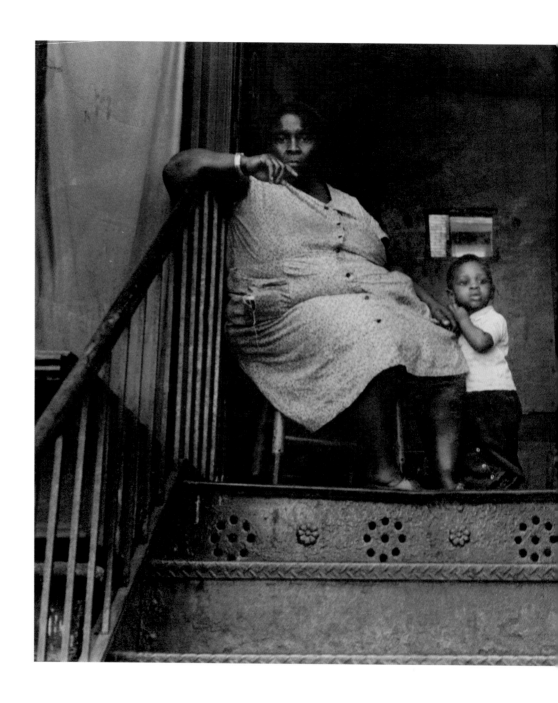

she be home soon babies

no need to fret / she gotta full-time job

at the hospital / she be tendin' to sick folks /

while i look in after you two / it's good

to set out here on the porch / can see all

the neighbors & the kids / one day

you'll be out there / playin ball or double-dutch

right now you here / & i jus bend yr

ears wit tales that don't even stick with ya /

but a minute / yet when i remember aunt lizzie

to ya / i aint lyin bout her / i jus want

you to hear bout yr family from me

i carry our heritage in my soul / i got to pass

it on to yr soul even if ya caint call it

by name / it's who you are & who ya come from

what matters

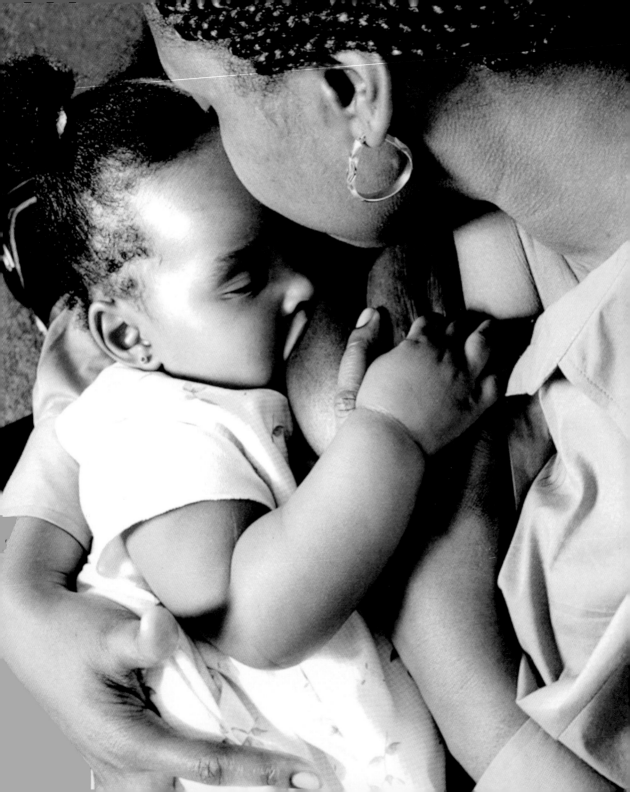

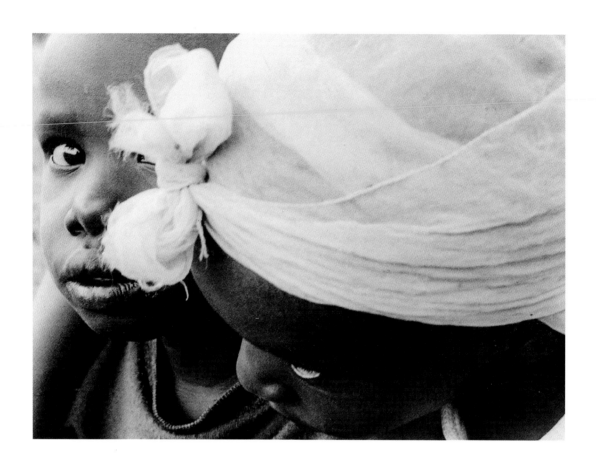

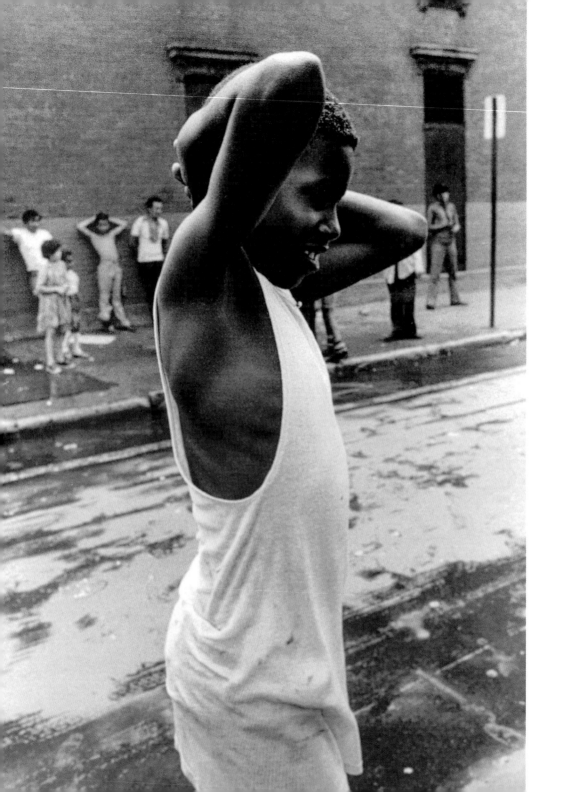

don't give up yet

my boys / so fulla gumption &
appetite / I cd feed em all the day
long / & they'd still / come back for
somethin / anythin' at all / problem is
they growin hand over fist / they growin'
& that cd mean some trouble
comin / trouble comin every which way
cd be some beggah boy wit
a knife or a gun / cd be a drive-by

mistake cd be the police / tellin
my boys to put they hands right
where they got em / locked b'hind
they necks / looks now they practicin'
for what they think is they fate
i'ma pray on that / Lord don't let
my boys play just thata way
no more / they got no call to lock
they hands that a way & I surely don't want em to
lord / let em be children
just a bit longer
til they men.

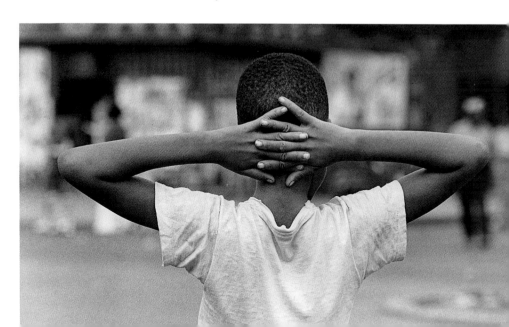

get up out that dark corner

yes the bar next door is gated up

but you don't wanna rap in there

yes the hip-hop community is still hard

one yng woman / but cha don' have to slink

down like that / interferes with your diaphram

& that's where you'll get your voice from /

there's power there / remembr queen latifah

don' slouch / neither do salt n pepa /

they strut around with they chests open / you

gotta do more than have somethin'

to say / to gotta believe what you sayin'

& stand up like you ready to rumble

with every ounce of sex you got / well as

yr sense of karma the

rha goddess / queen godis / & missy elliot can

attest to that / remember "Ladies First"

well yr the 2nd generation or maybe the 3rd

generation of yng women ready to say they

piece / it's gonna be hard / but first you gotta

stand up / strut & let your words dazzle the crowd

ya gotta get off the stairs / out that corner

take your microphone & announce to the world

on that you got somethin that's gotta be

heard

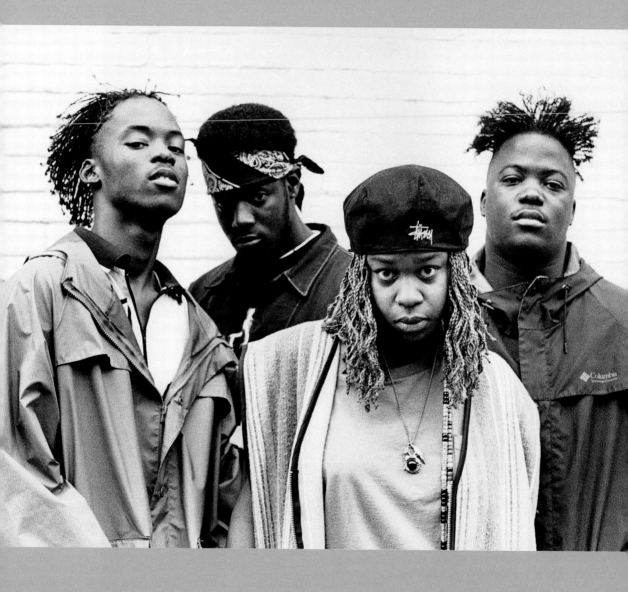

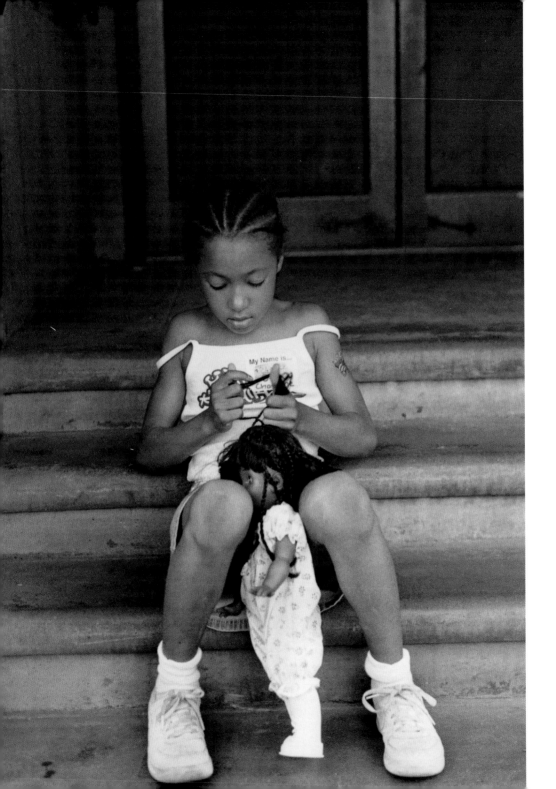

porches come alive with the chatter of infants

the wonder of the afternoon's surprises

lookin' beyond ourselves and to ourselves

for the fullness of the day

our lives under a beret just beyond

a railing / can you feel it

the pulse of tomorrow while I hold the

baby / can you feel it

i'm talking to tito now

why won't he listen to me

the day's barely done and my arms are

heavy with tomorrow / here you

hold tomorrow on your lap

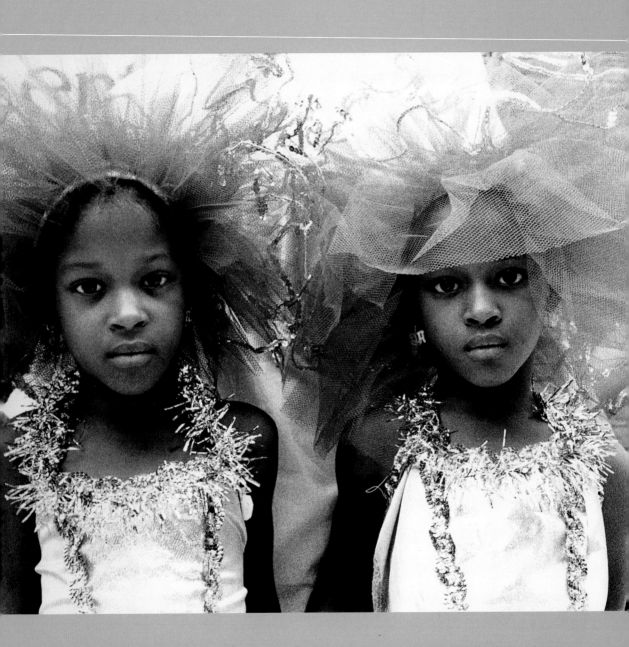

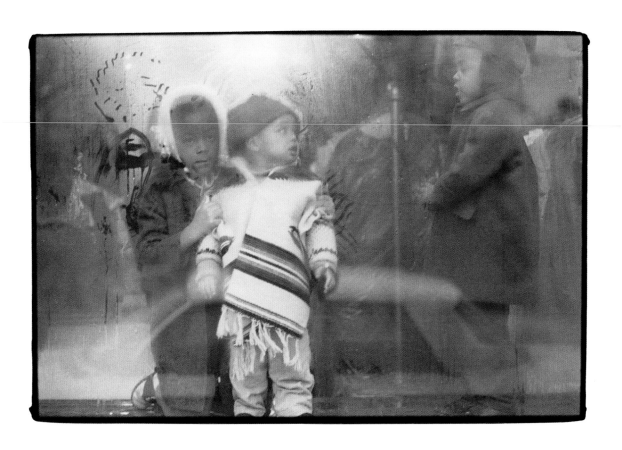

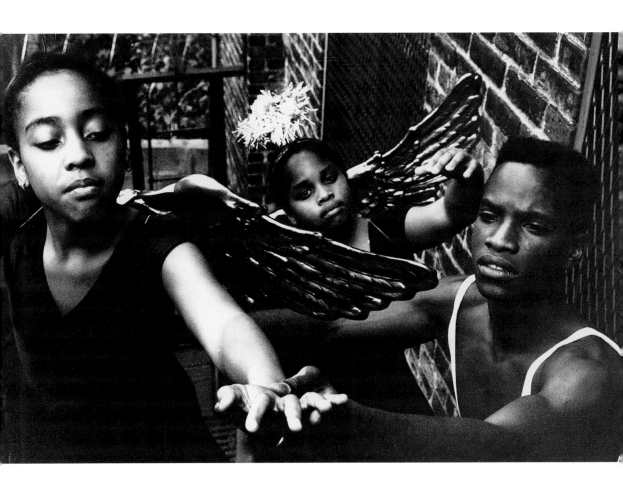

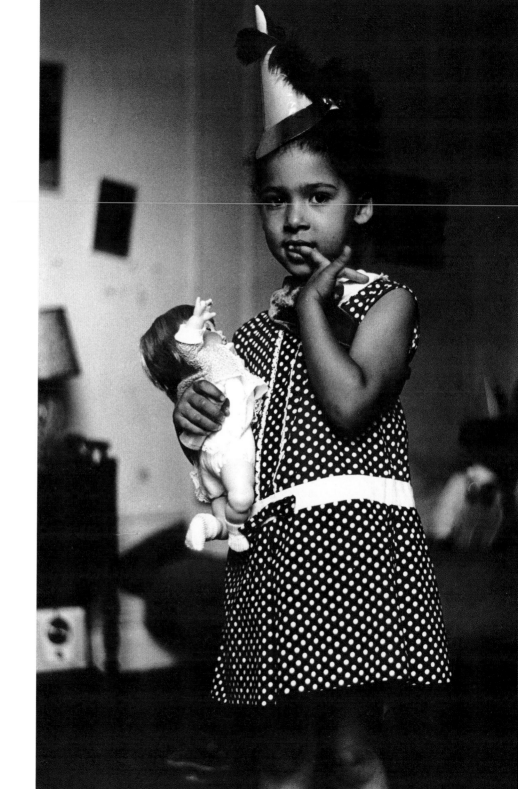

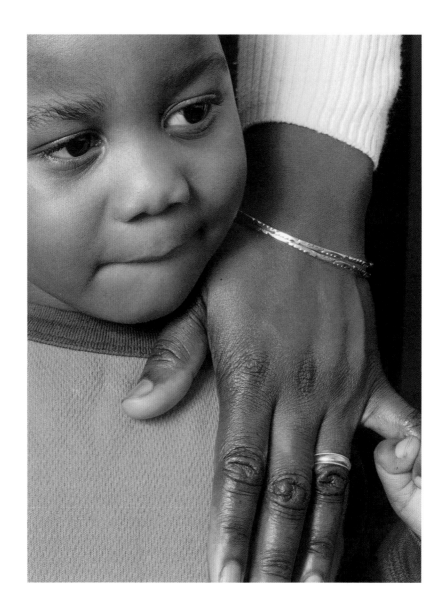

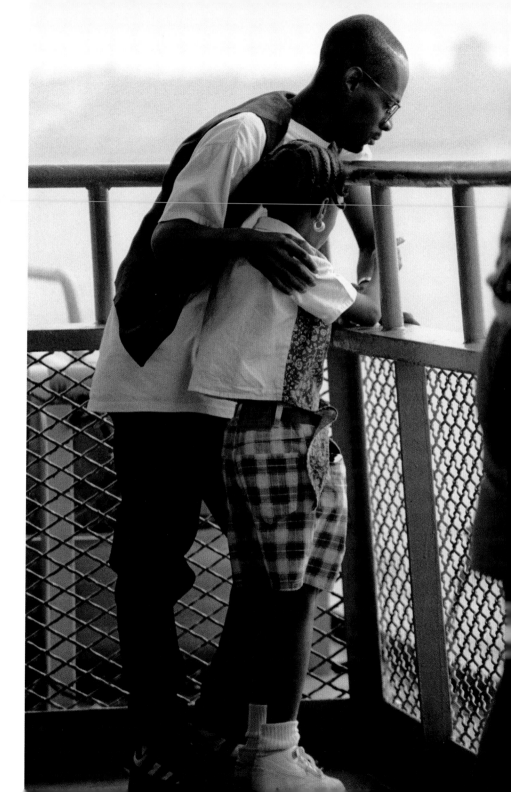

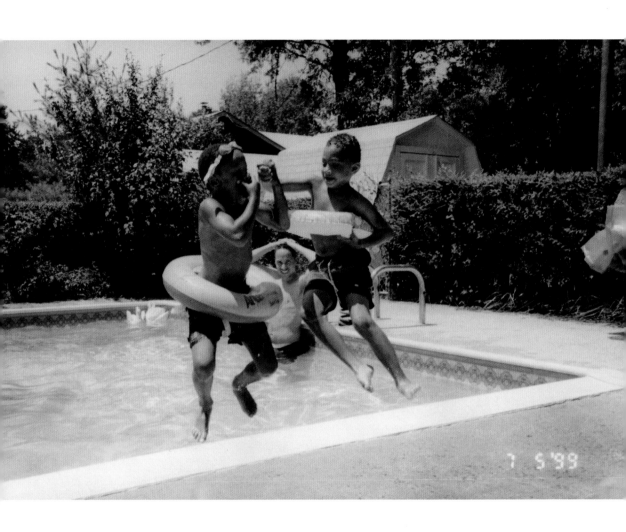

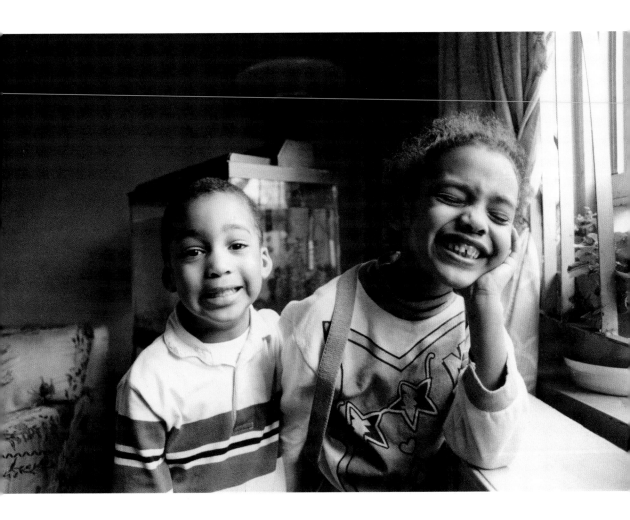

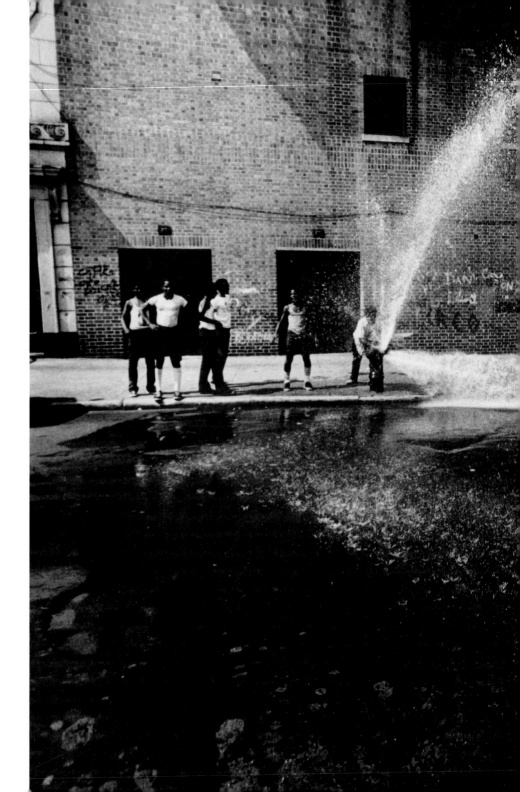

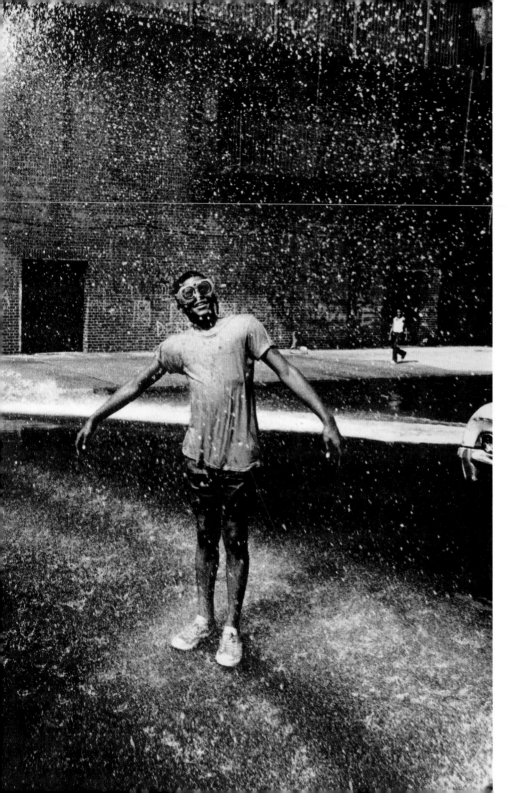

playin'
no matter what

he's out there / in the rain

with a tire / & half naked /

cdn't wait for the hydrants

to be opened & all the othah

children to come play / oh no

rain peltin his skin is good

enuf / for him & sloshin that tire

thru the streets he's like a commando

makes him smile & the hydrants

aint even on / it's jus' him & free time

& the rain

but on sunny days there's always

abandoned cars to explore / to pretend to drive

to climb & choose to climb / explorers

of the city / we aint got much

but our kids do have a yard

it's the city / we lucked up there

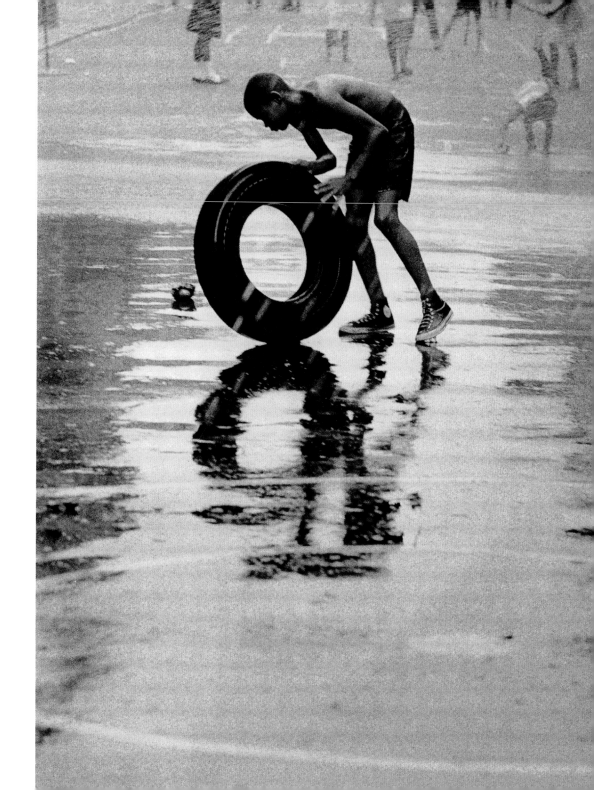

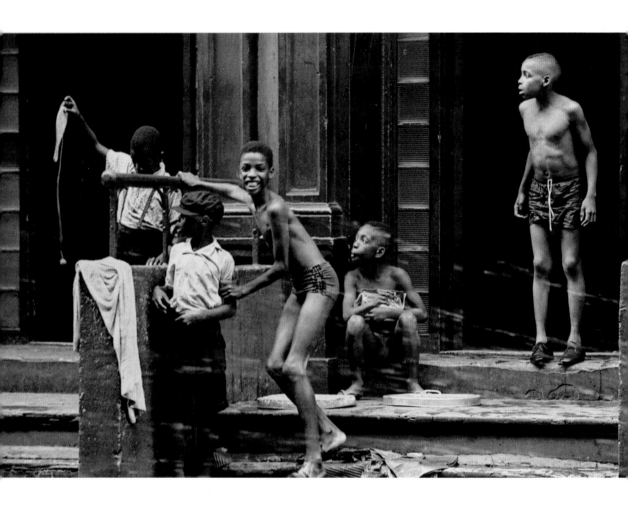

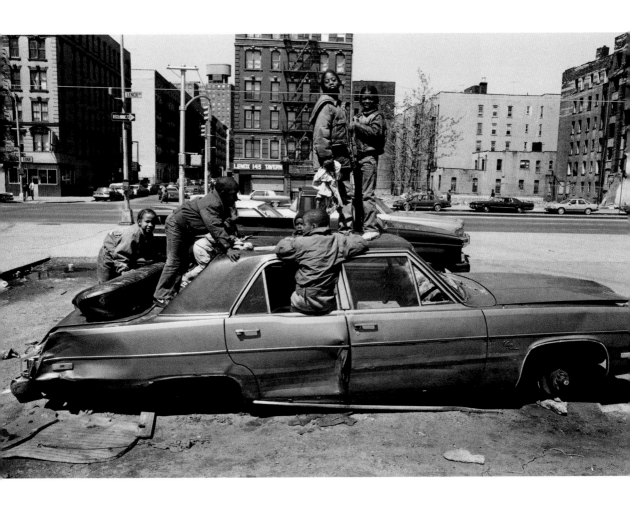

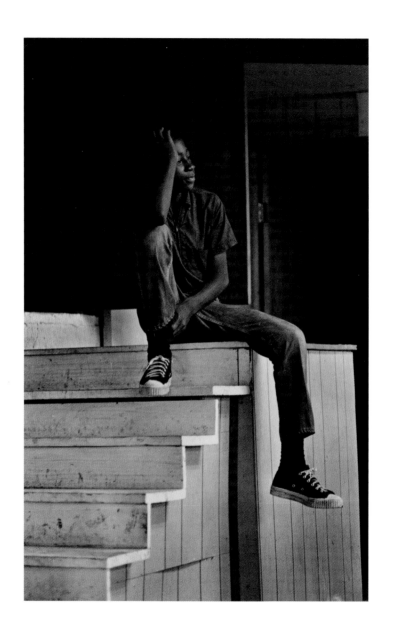

CENTRAL IRON & MET

30 STRAIGHT ST. MU. 4 -

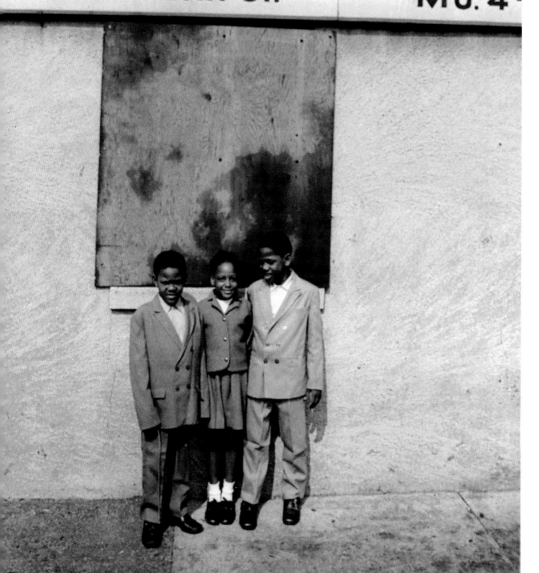

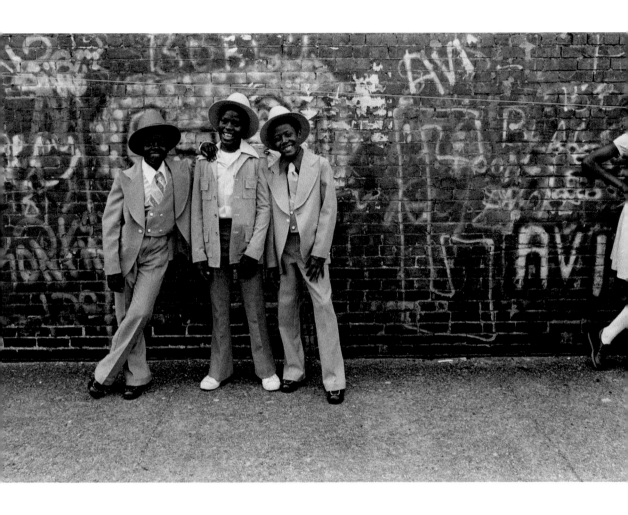

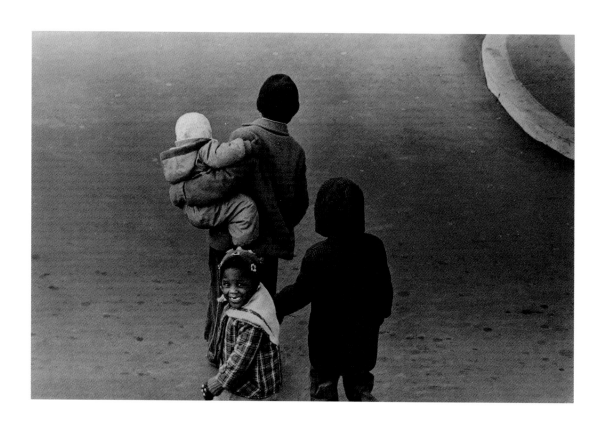

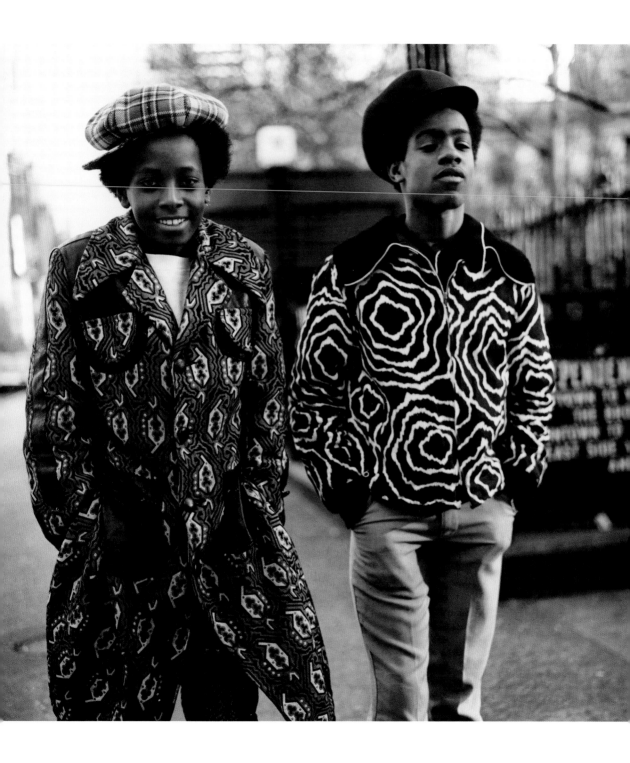

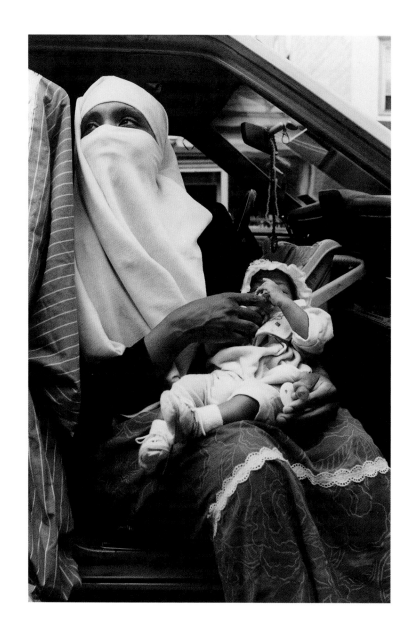

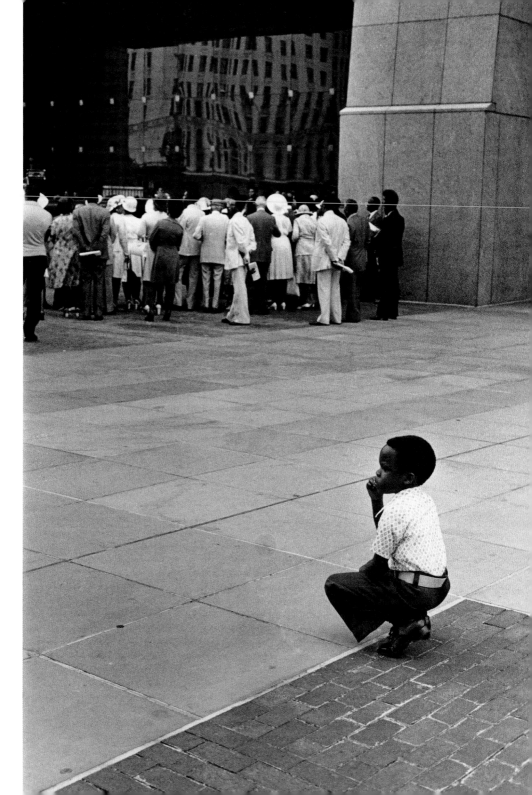

i believe it
too

she knows that isn't sposed to happen to her /
her nose is flat / her skin sepia / her
hair nappy / it's not sposed to happen here
fidel declared cuba an afro-cuban nation
that's what they taught her / all her life
but she knows better / she's still too
african to work at the tropicana
in feathers and satin / she's never
gonna head a ministry / she might not even
marry / some novio's family furious
with her just 'cause she's too dark
for their son / makes them remember
when in better times / people like that
la negra washed their children & their
toilets / she's never heard pedro's words
"to be called 'negrita' is to be called love"
i wish she cd hear now / baby i'll do her hair
& massage that frown away.

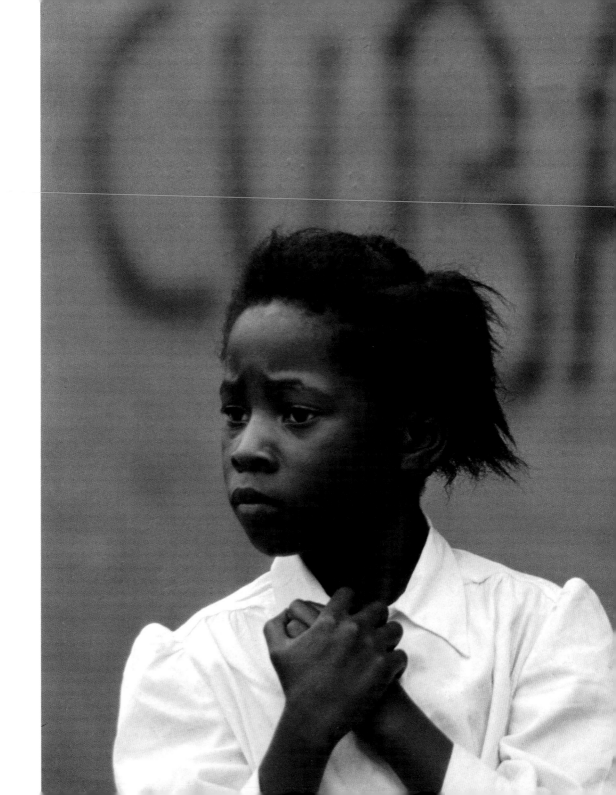

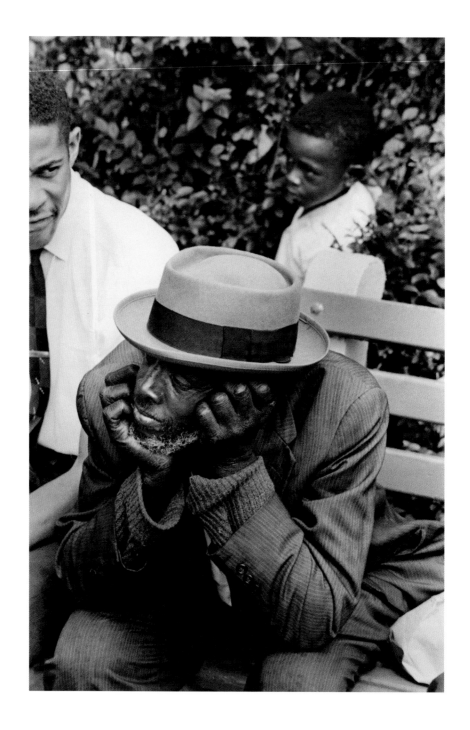

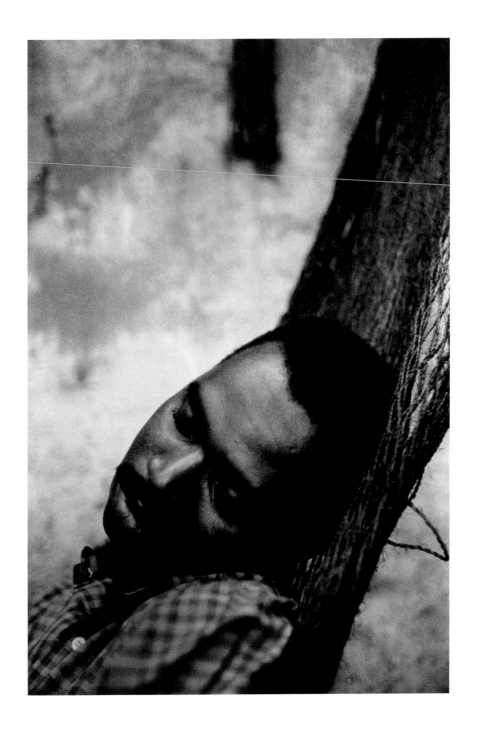

right from richard allen to Elijah

what are you? deaf? elijah muhammed

shouted that at you every day of his life / even

wallace fard muhammed before him / & there

was garvey with all his black people declarin'

themselves by the thousands in they uniforms

paradin' down the streets of harlem

as africans / but you didn't hear him / rejoicin

when they feds got em / didn't hear til malcolm

and even then you cdn't save him / what about

h. rap brown / he wasn't always a messenger

of allah / he represented you / but no y'all

got pictures of jfk & robert kennedy right next

to jesus / do i sound mad / well i am mad / i been

waitin for ya to hear somebody to get

these white folks off my back / and still ya

aint hearin' nothin' bout freedom / aint

heard folks what love ya with all our hearts

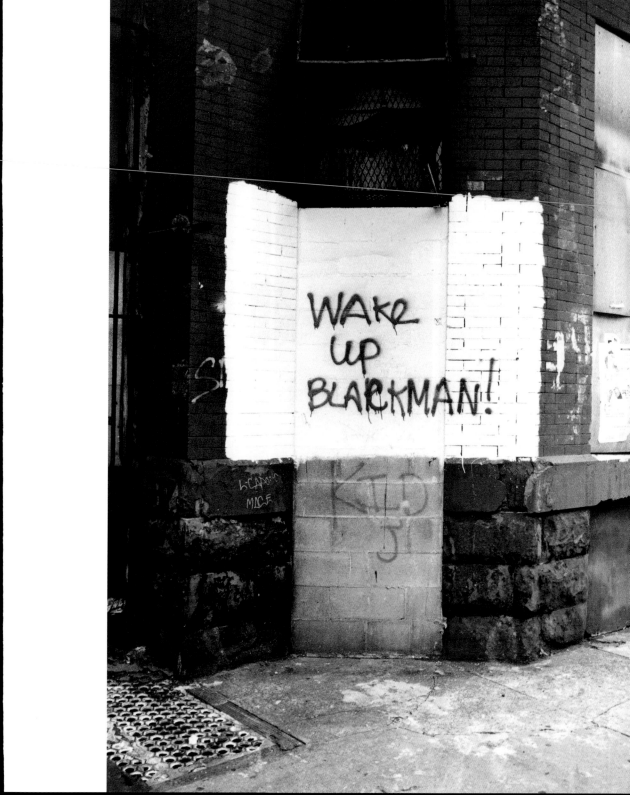

black man cryin'

say brothah, what happened

somethin' terrible musta happened

so rare to see a black man in such pain

and a tear strewn face

cd it be bout one of yr children?

yr mother? yr girlfriend or yr wife?

i can't stand to see you suffer so

looks like you gonna scream or those

sobbin sounds gonna sneak out yr mouth

like curse words used ta / was it a fire

that trapped all yr love ones? please

tell me so i cd comfort you/some how

yr eyes are so sad / the tears so unavailable

yr face contorted / oh brothah-man

please let me hold you / aint one person

sposed to weep so / all by himself

aint one person to stand in the night sky

feeling worse that muddy waters

wailing

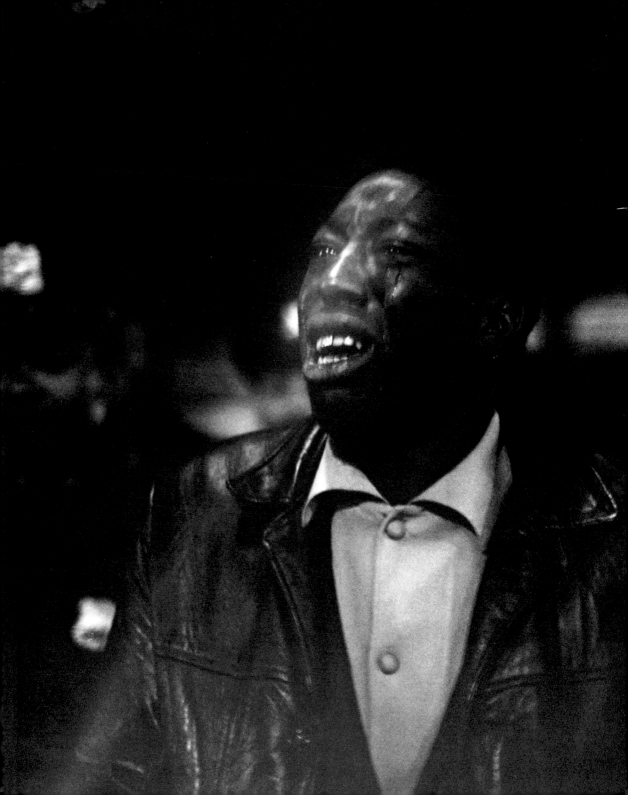

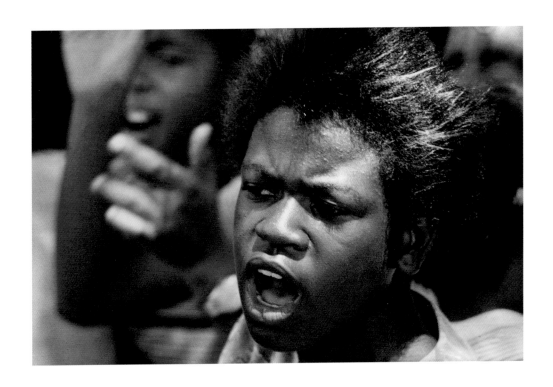

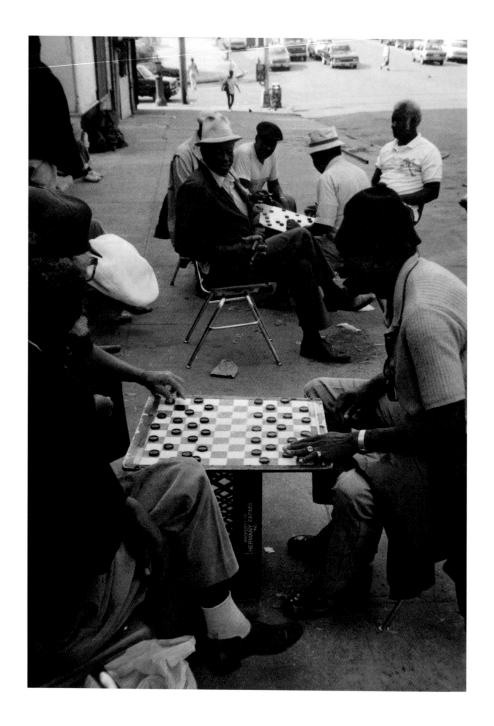

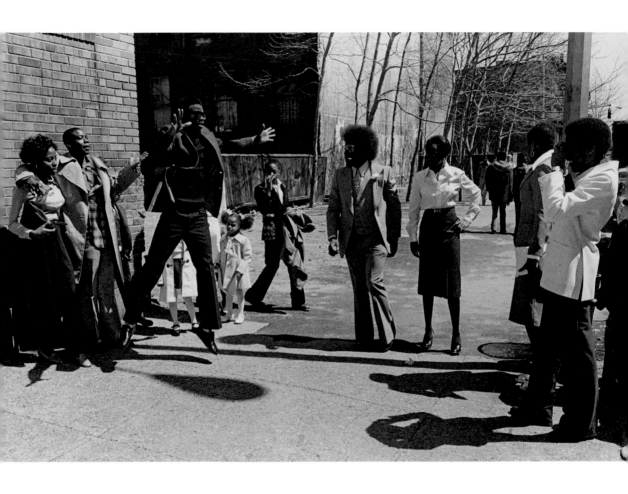

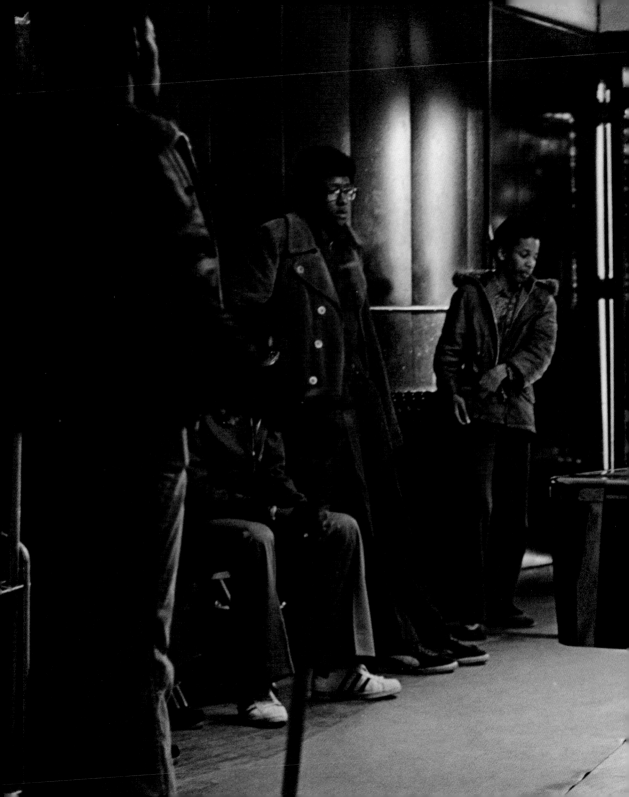

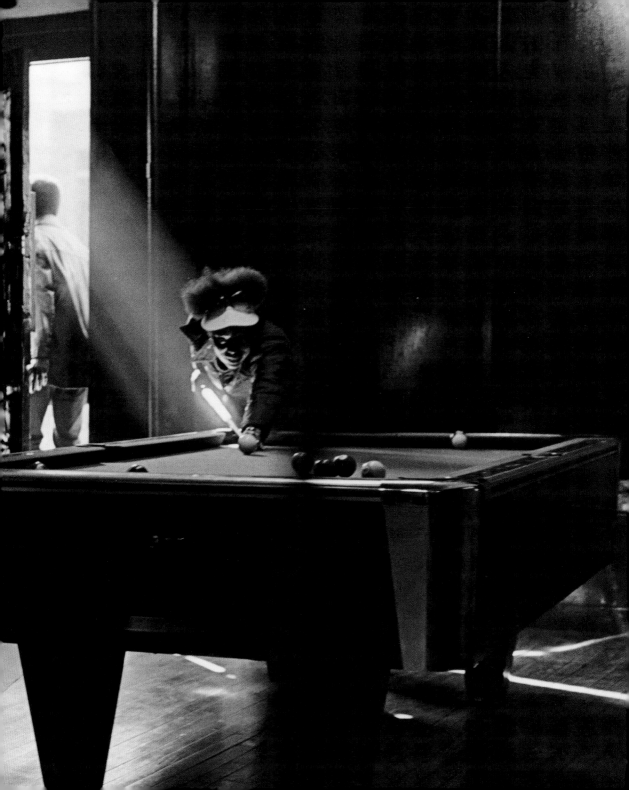

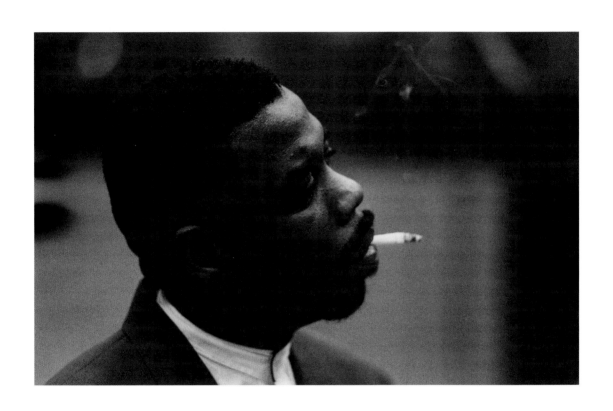

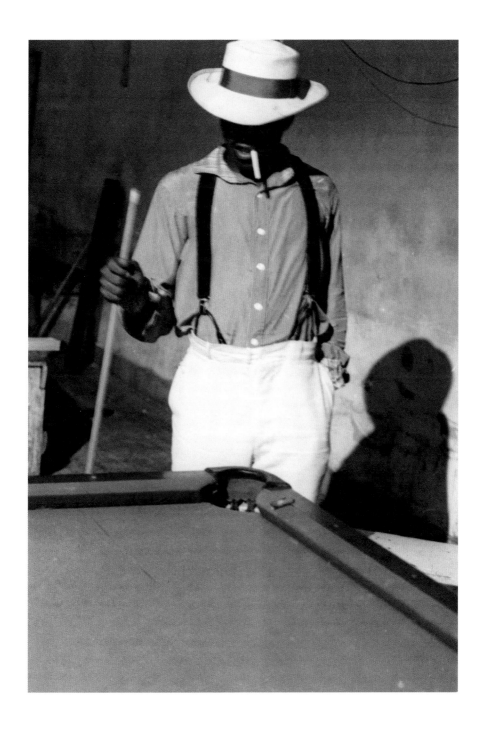

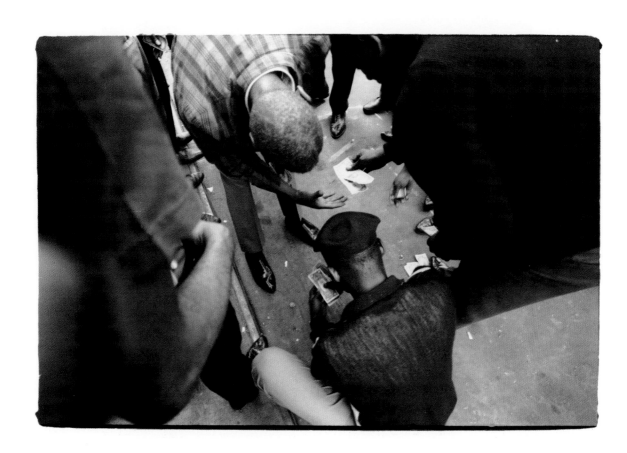

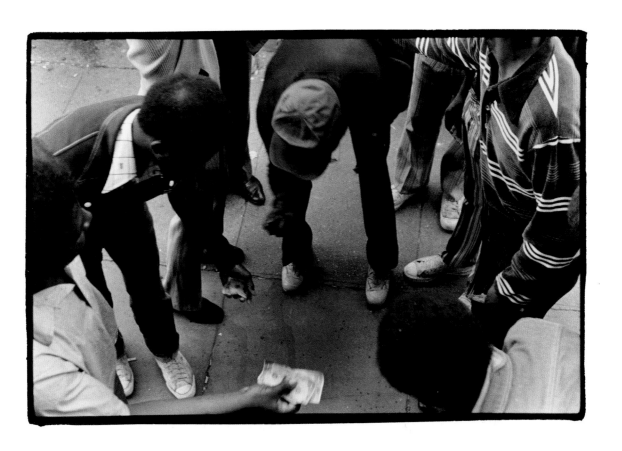

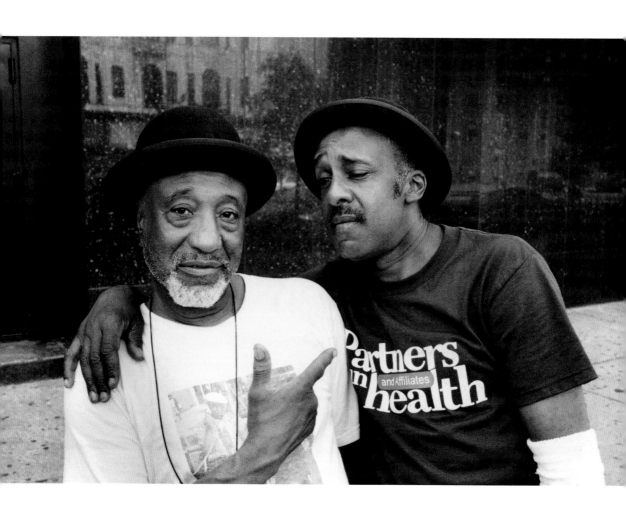

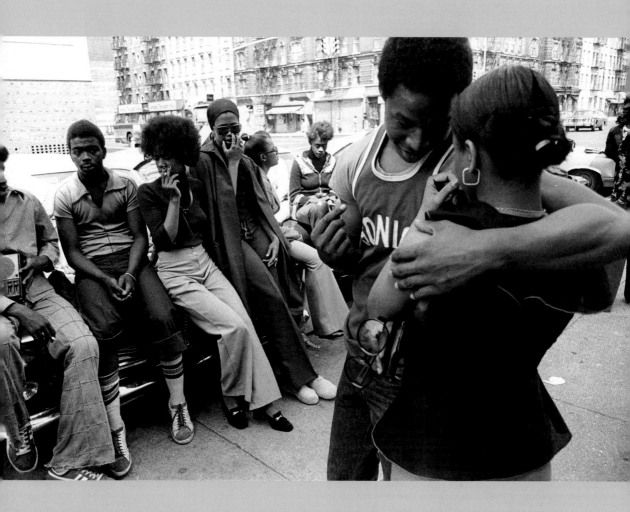

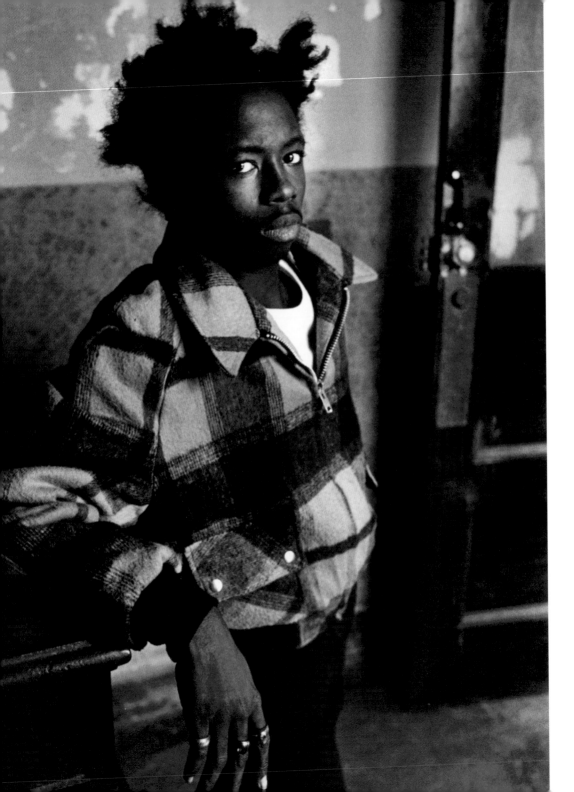

i can't take this anymore

once i saw a dope-fiend heroin addict

in a nod / fall straight down on the platform

and crack his skull right open / his two

friends saw blood gushin' & ran on off 'fore

the ems cd get there / brothah don't you

know you cd be dead or robbed or awakened

with a nightstick straight cross yr back

i'm tellin' ya there's no sympathy for

you a black man in blackout by himself

on a subway train / ya bettah get out of there

'fore the rush hour come / & so called

clean livers come and stand for away from

ya cause ya black probably stink &

out yr right mind / nothin good comin' to ya

a lone blk man out yr right mind on a

train that's carrying a jumble of folks on they

way to work / if ya wake up / can ya act like a

man & look em in the eye & act like you got somewhere to go

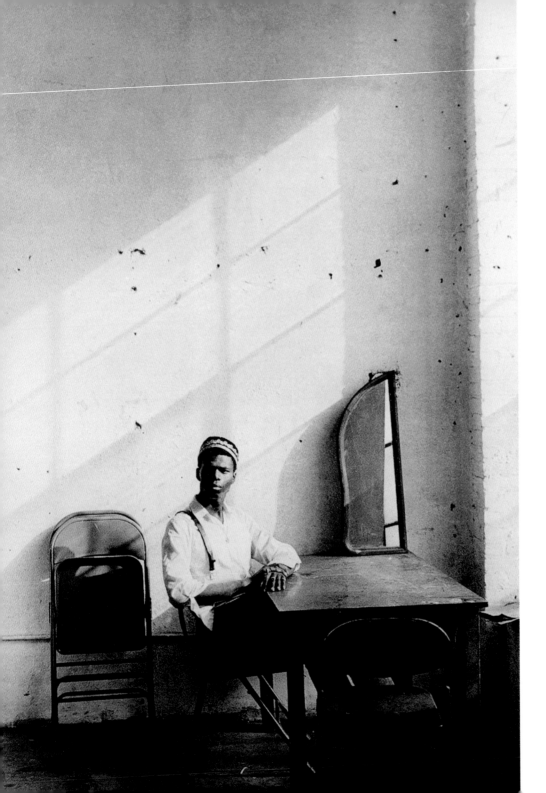

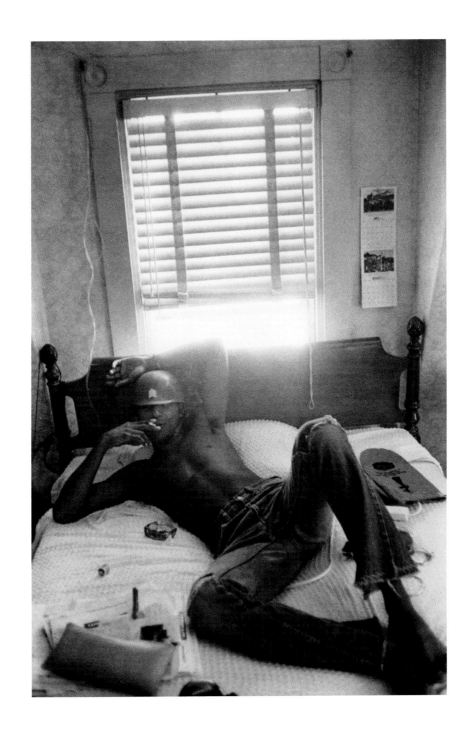

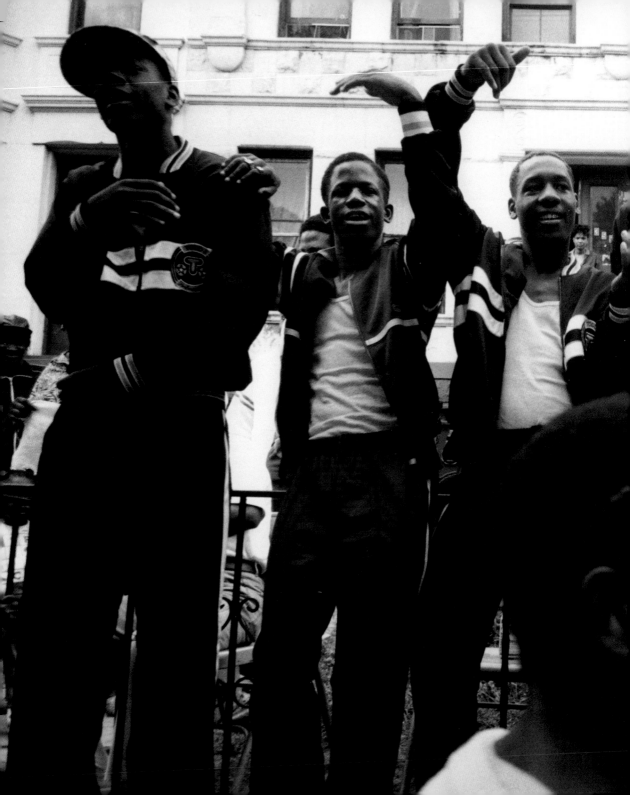

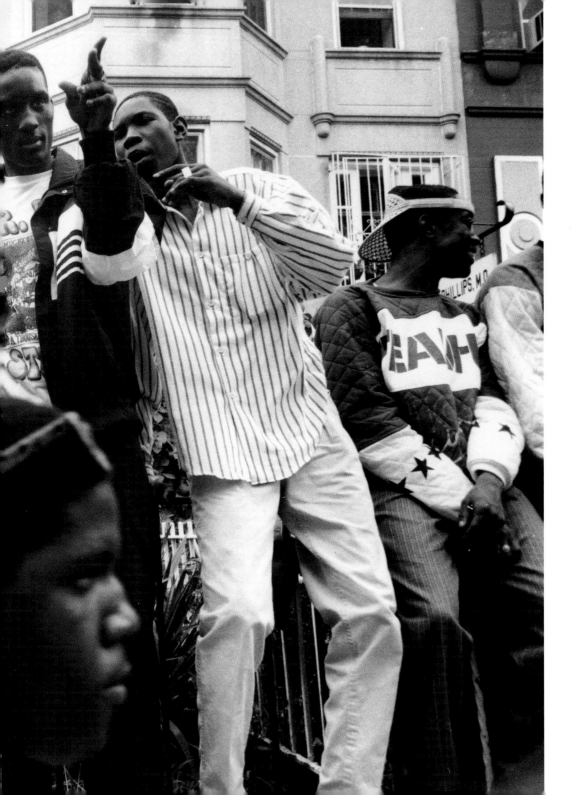

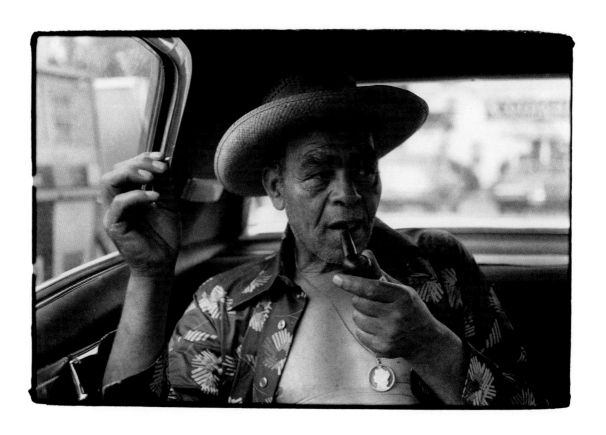

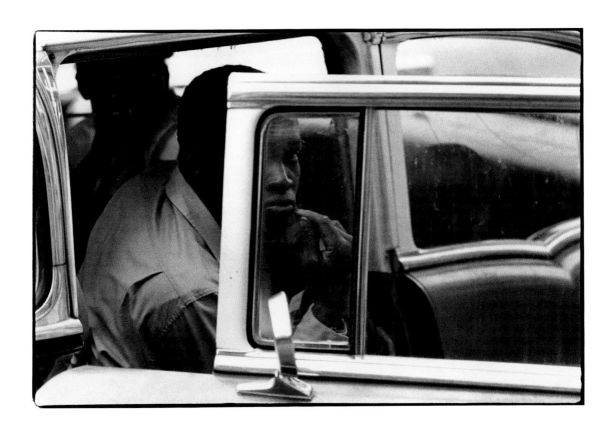

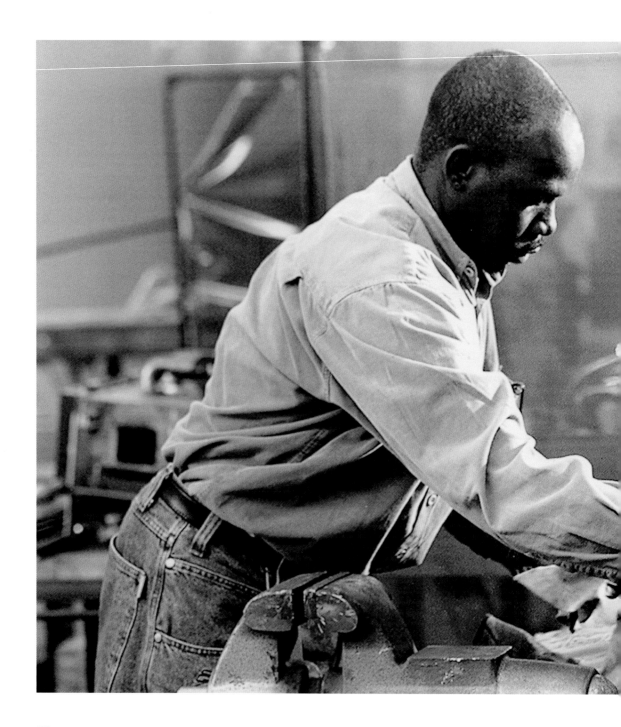

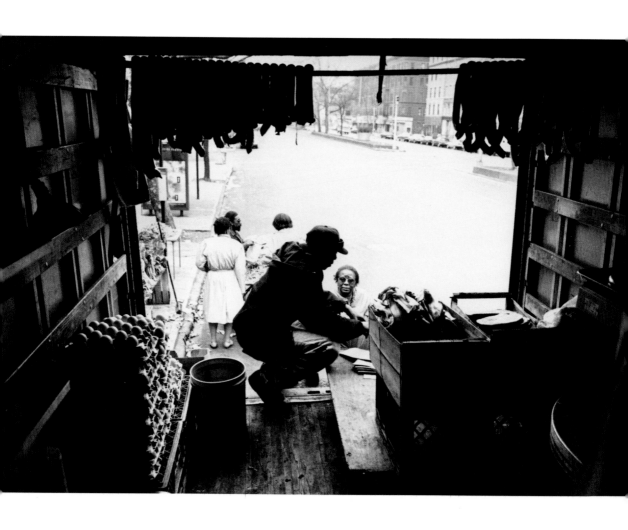

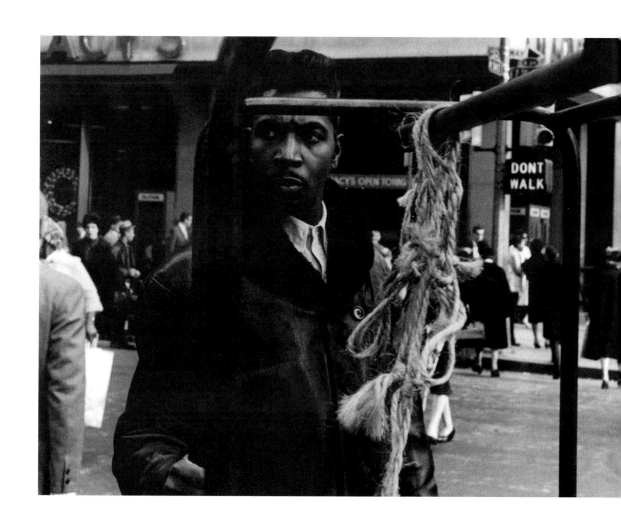

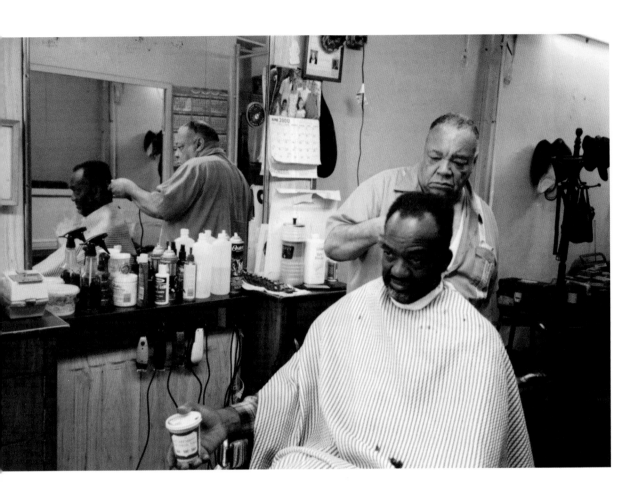

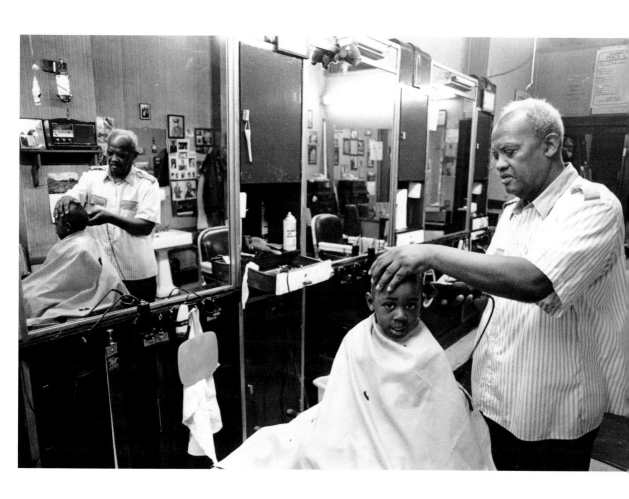

i'm still holdin those roses

i promised you

the train must be late but

i'ma wait on you anyway

i promised you not to let

you down / not this time

i'll keepa holdt to this

bouquet till your cheek

is next to mine & where

we are is simply fragile

as another petal of the bouquet

that's really what I want from you

tenderness

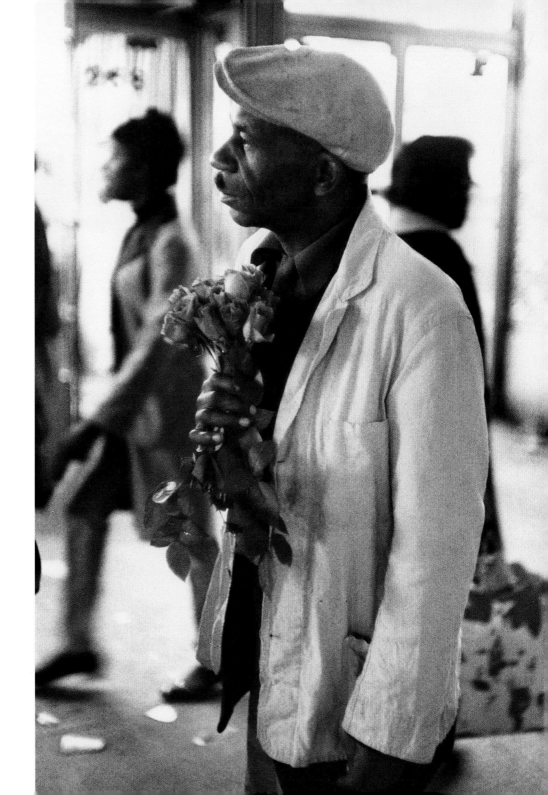

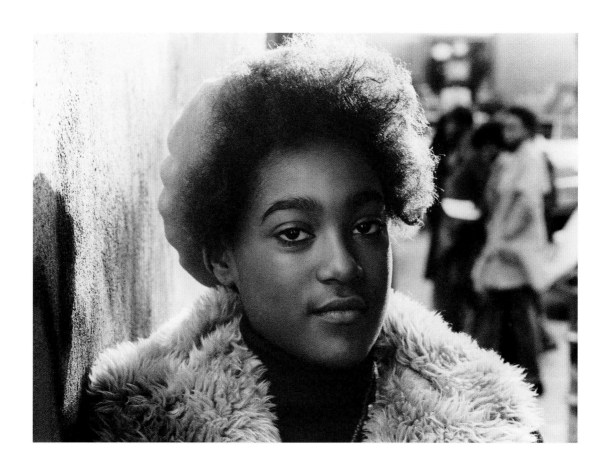

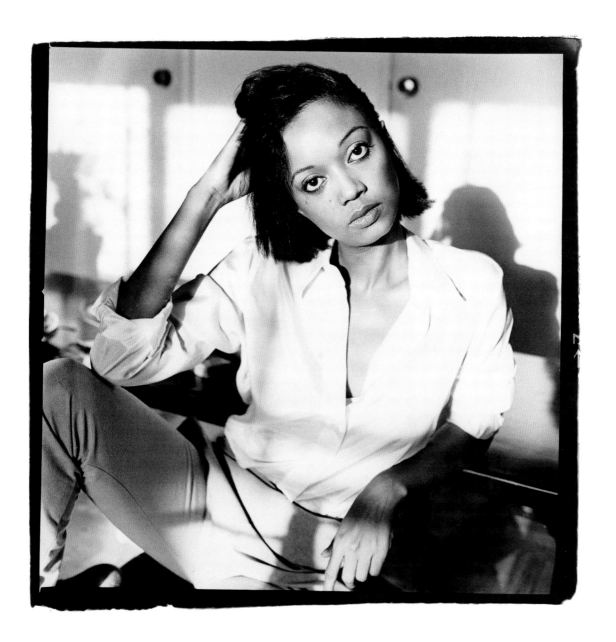

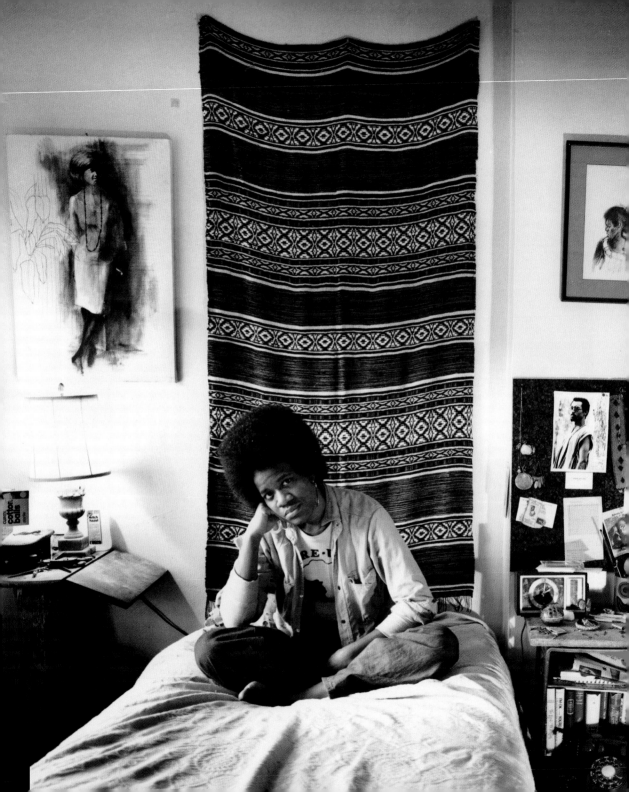

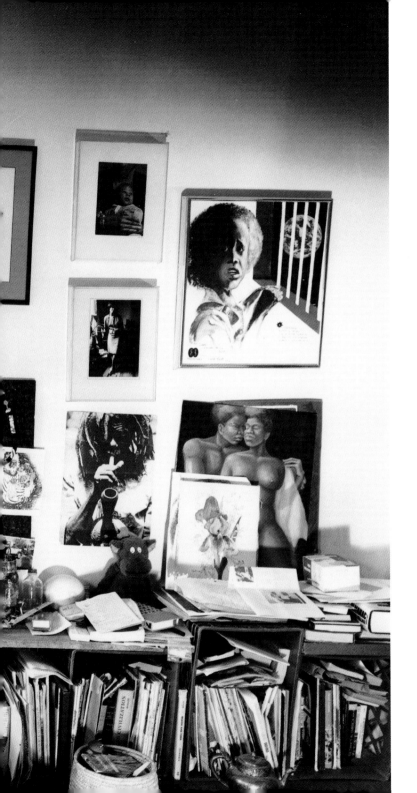

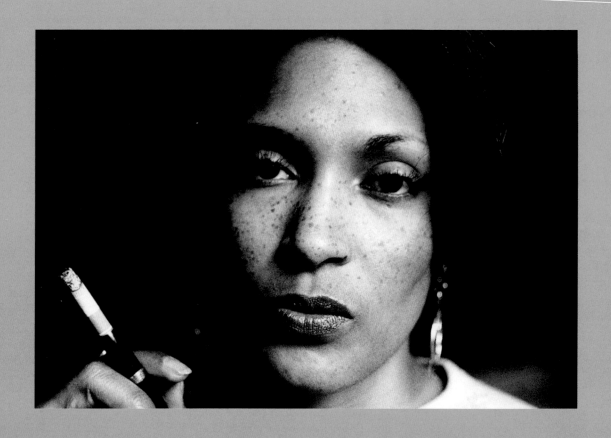

wow, wd I like to get next to that

she's alluring & sophisticated now
but that masks the call of redbone
when she was young
redbone rhiney maybe even high yellow
shouted at this beauty as she ran
home desperately trying to escape
the taunts / rumors spread about her
that she was uppity & easy / folks
cdn't make up their minds / just cause
she had freckles and ran from them
which gave them a sense of great power
their meanness shouted with glee
their name calling laced with lewdness
how cd she survive in a colored world
that laughed at her cause of her skin
that peculiar skin tone laced with freckles
she is beautiful now / but gaze into
her eyes where she suspects rejection
from anyone who dares to love her
now she's alluring & sophisticated.

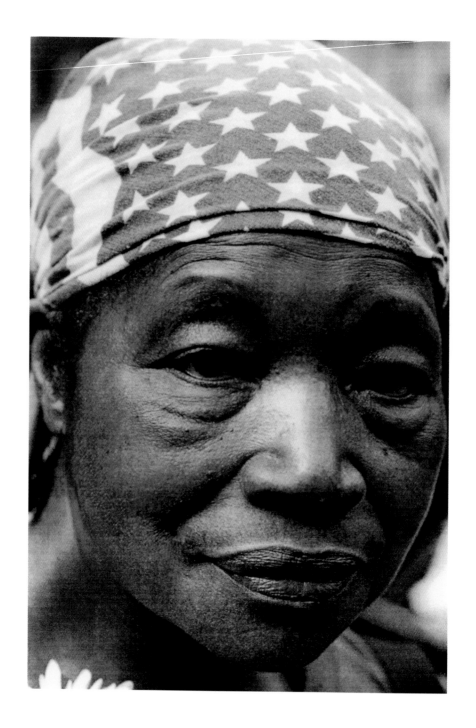

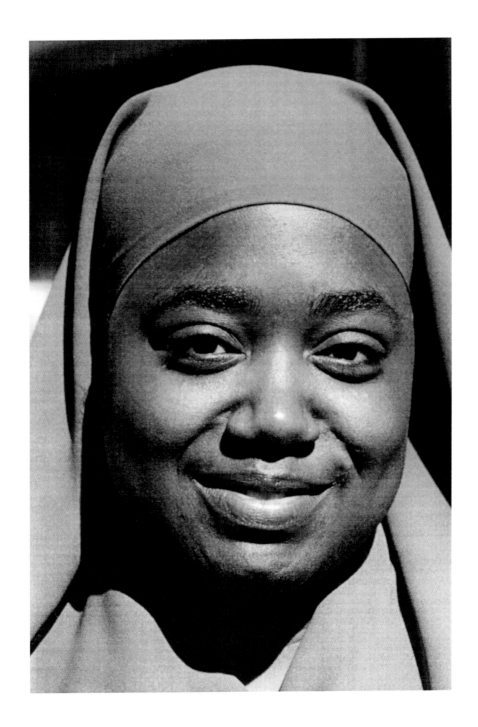

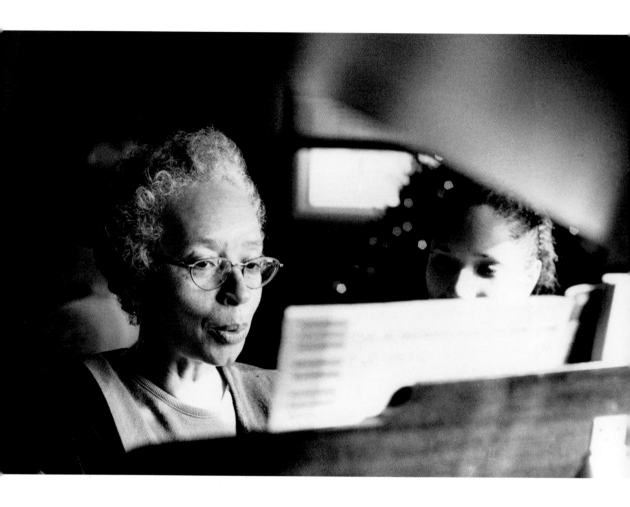

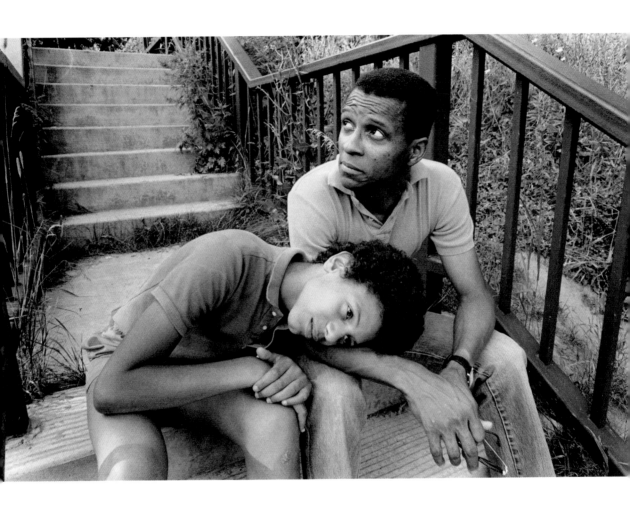

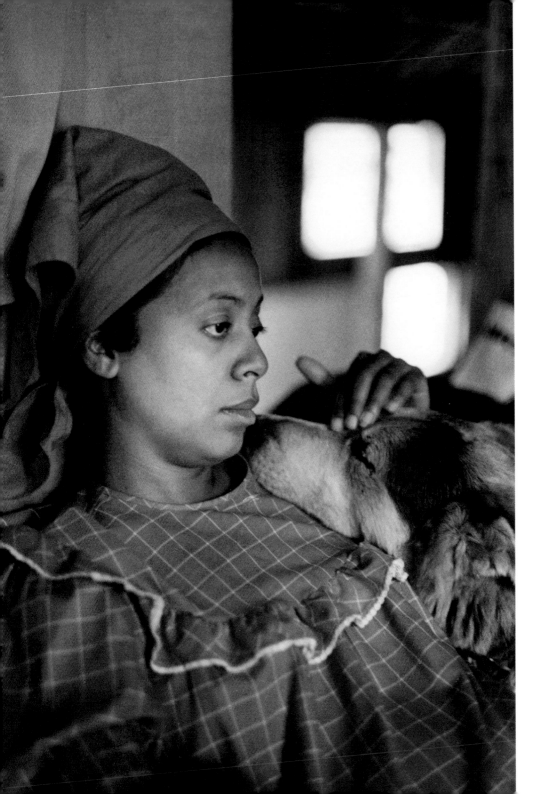

chillin with child

yes awright / she barefoot & pregnant
but she's reading & world that opens
she's not reading *dune* or *love & rockets*
either though i loved them both
she's reading a text in the light of day
with small print / a serious book
she may be pregnant / & shoeless
cause it's comfortable / but she aint
ignorant just cause she's with child
maybe she's listenin' to some jazz
all that culture and information
'bout archeology or *beloved* or
nkrumah is sinking to the nexus
of the baby's unconscious
they say everythang we do while we
pregnant effects the baby
this yng woman maybe barefoot & pregnant
but her baby sure will be well read
& gotta yen for great blk music

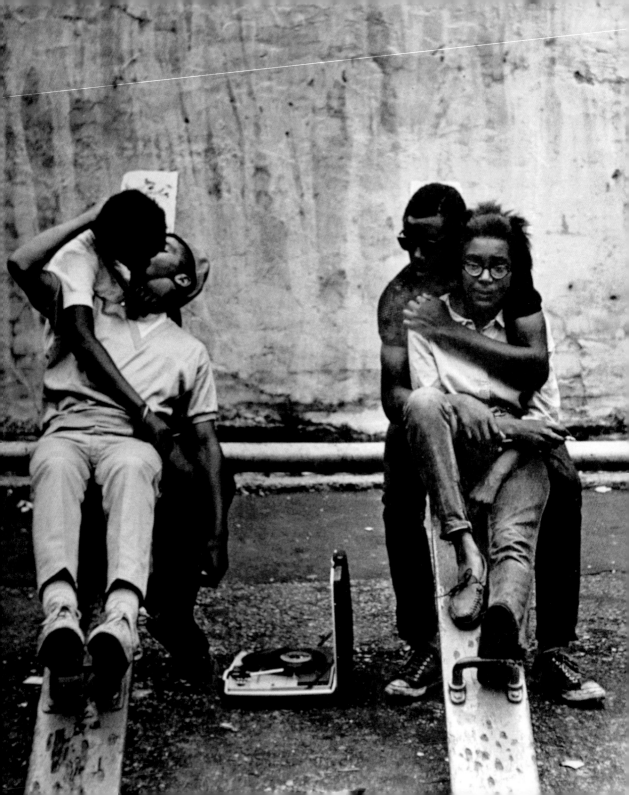

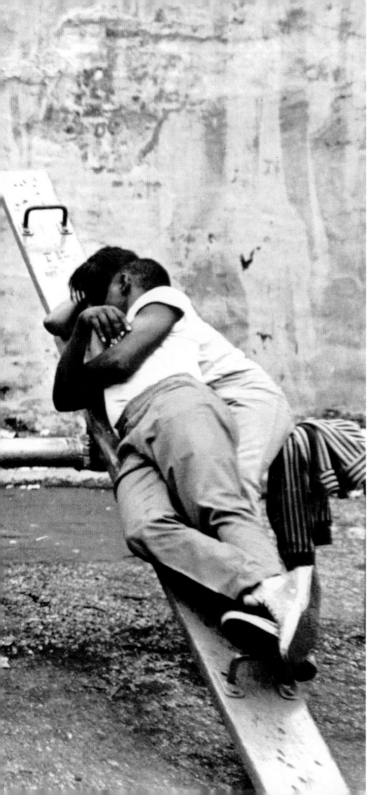

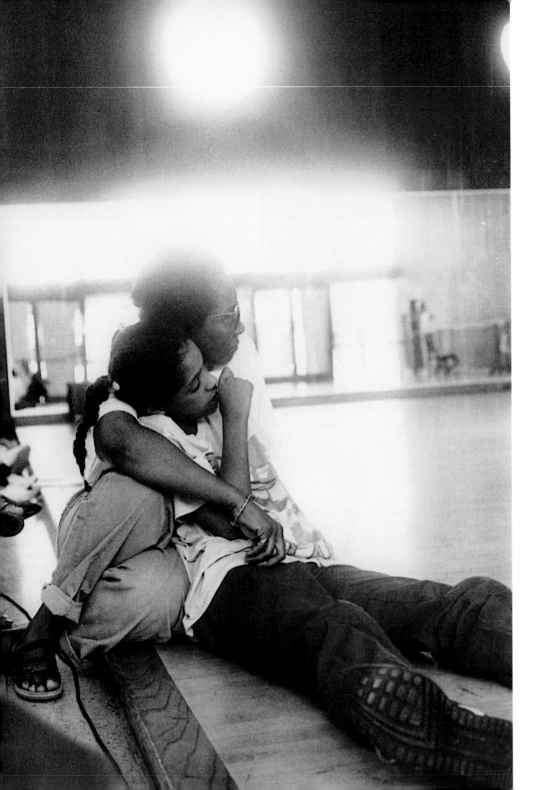

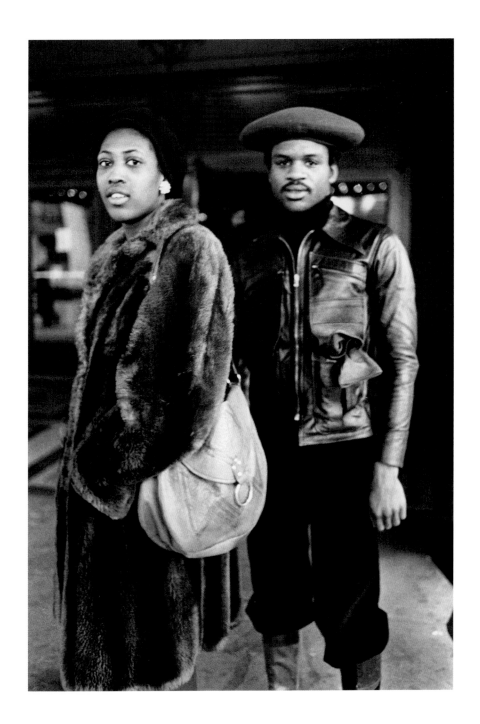

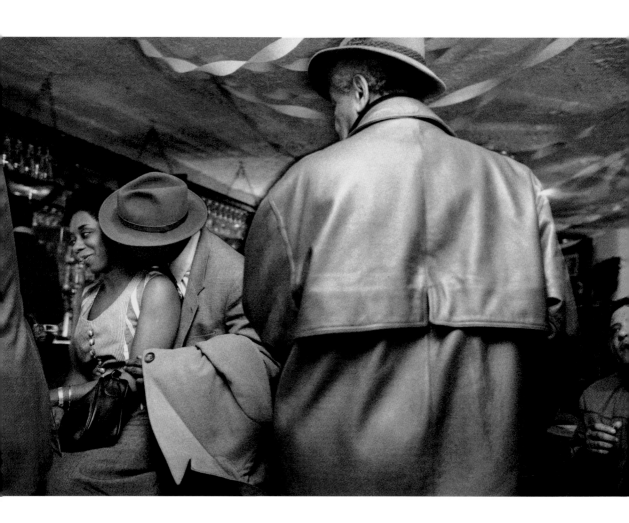

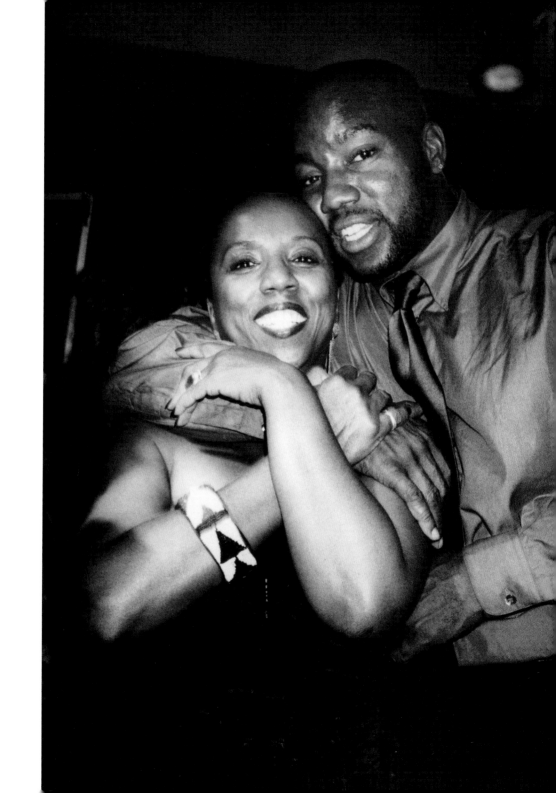

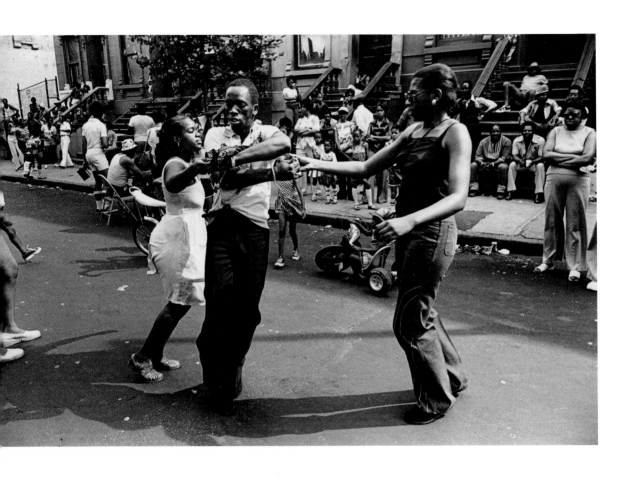

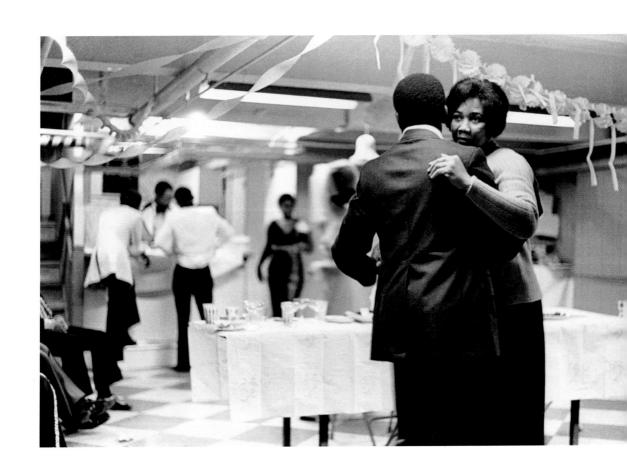

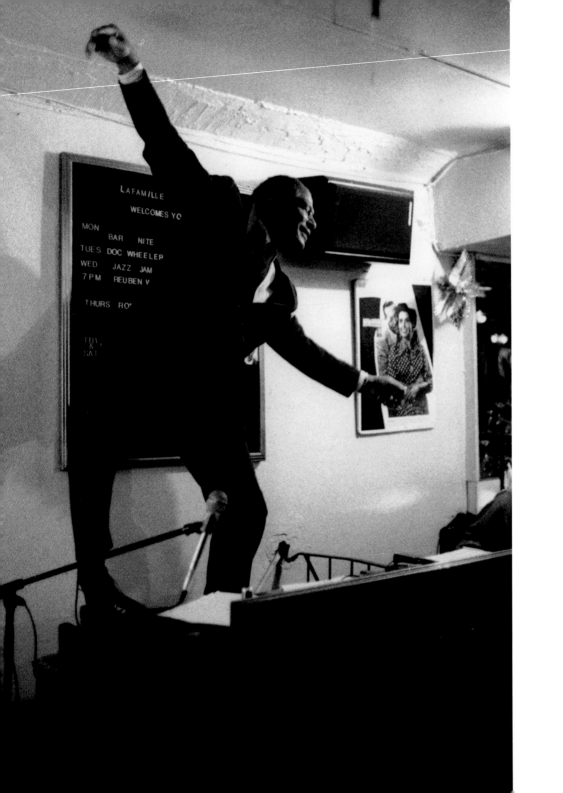

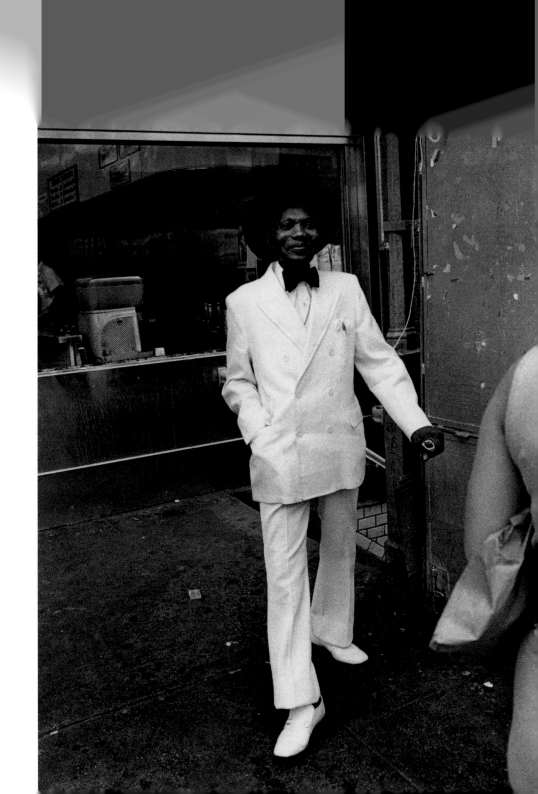

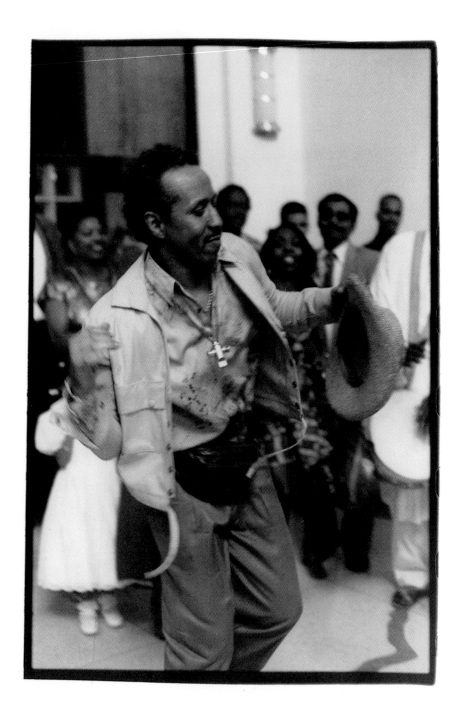

the dancin series

folks say we start dancin' / soon as

we can walk / our little backsides

start to bob this way & that / our

arms weave in the air / to rhythms

we now know are holdouts from africa /

we don't know that / but we can dance

anyway / why we improvise from age one

people laugh at us cause our dance is

our own / while the grown-ups & the

teens dance / dances with rules & strict

roles for girls & boys / some times the men &

women seem just to lean on each other /

swaying back & forth / but no matter / we

dance from the time we cd walk &

the music & that beat never ceases to

challenge our little bodies to find

another limb to move right on like

labelle or the jackson five / my mama

likes that music / reminds her of when she

was little like me / just beginning to get

hold of my colored instincts / after all i am

just a tiny african & i got to do what africans do

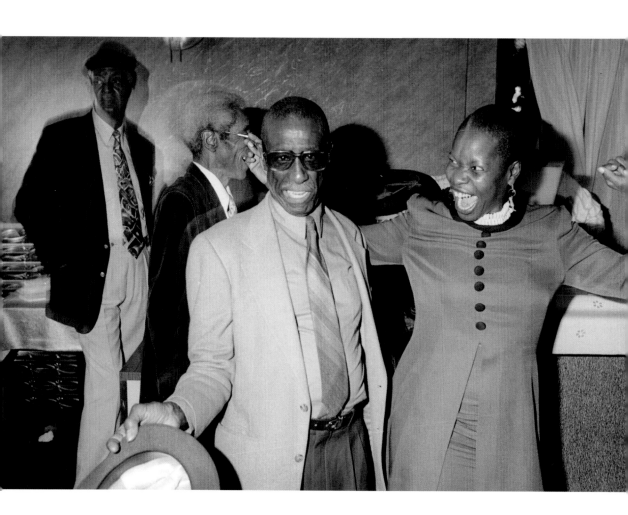

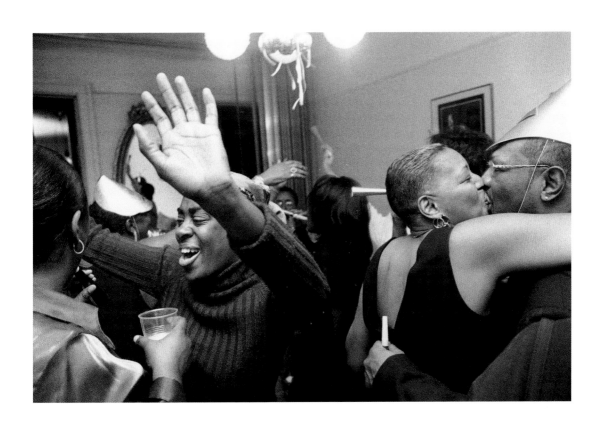

the spell is colored

the night black and jim beam

come closer to me baby

the aroma of beragmot and

sunflowers is too much to resist

dance with me baby

your body liked to be part

of mine dance with me baby

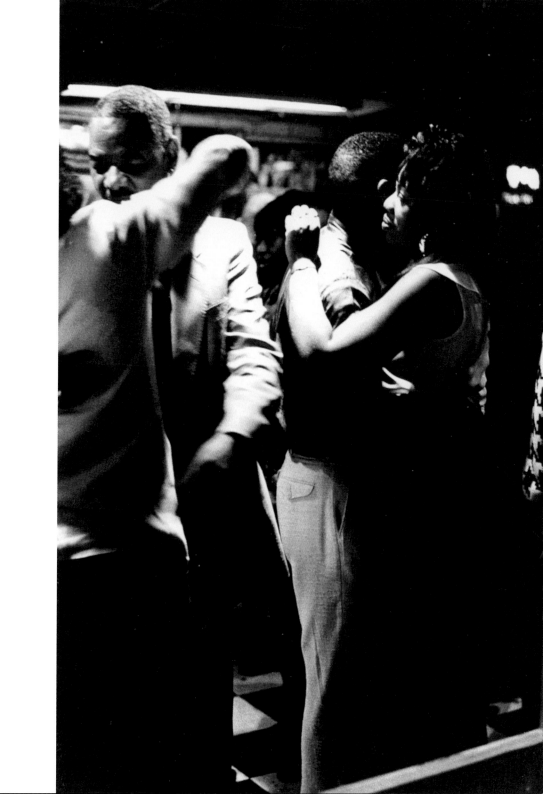

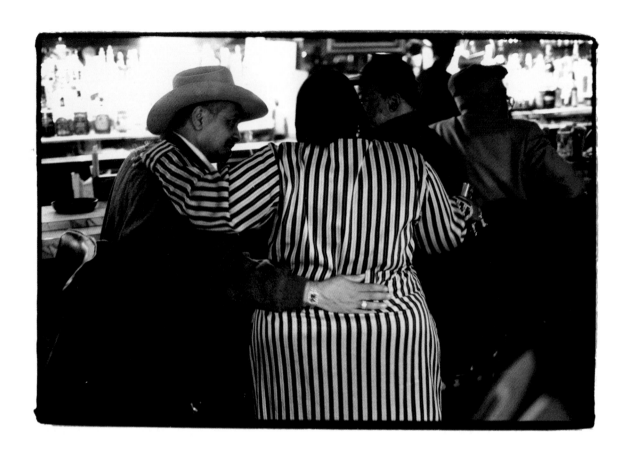

aqui me quedo

"hóla, señora" that's what i say
to her every mornin' when i go for
my café con leche / i welcomed her
to the neighborhood / it's good to hear
somebody not speak english & play
merengues all night & day
doesn't matter if the tablecloths are plastic
or a sticky kinda placemat / doesn't matter
if the cook gets my order mixed up/
they listen to my broken spanish / let me
read their *el diario* tell me / i look
like other dominican women / tell me
what other dominican stores i should
support / where there's good jewelry / good
groceries / & reasonable round-trips
to puerto rico & the dominican republic / all
this comradery / while i sip my second or third
café con leche / sí senora "aqui me quedo"
is a wonderful name for the restaurant
i hope the english speakers never run you out.

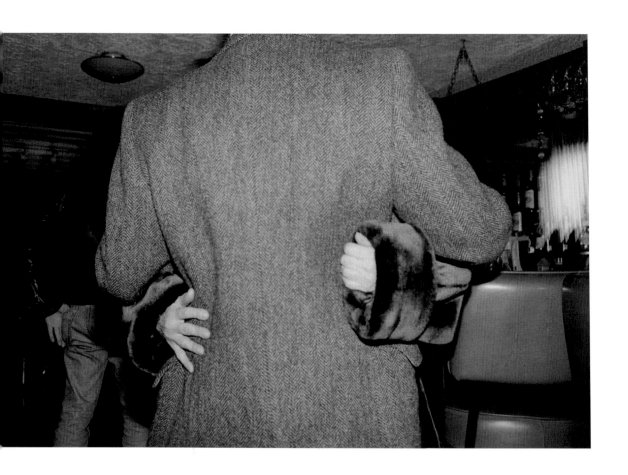

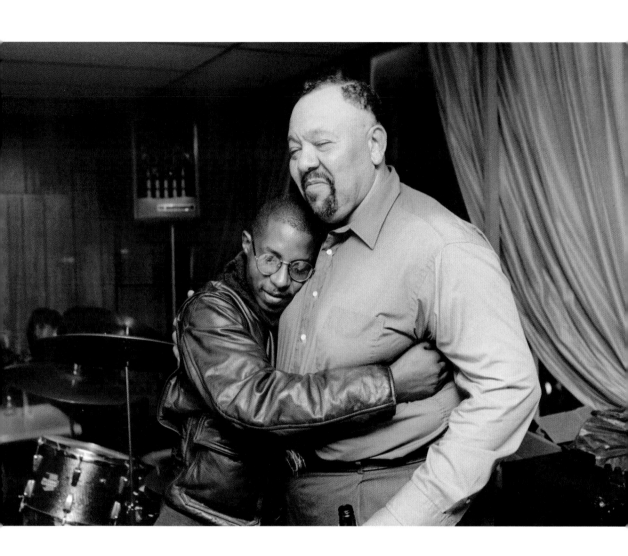

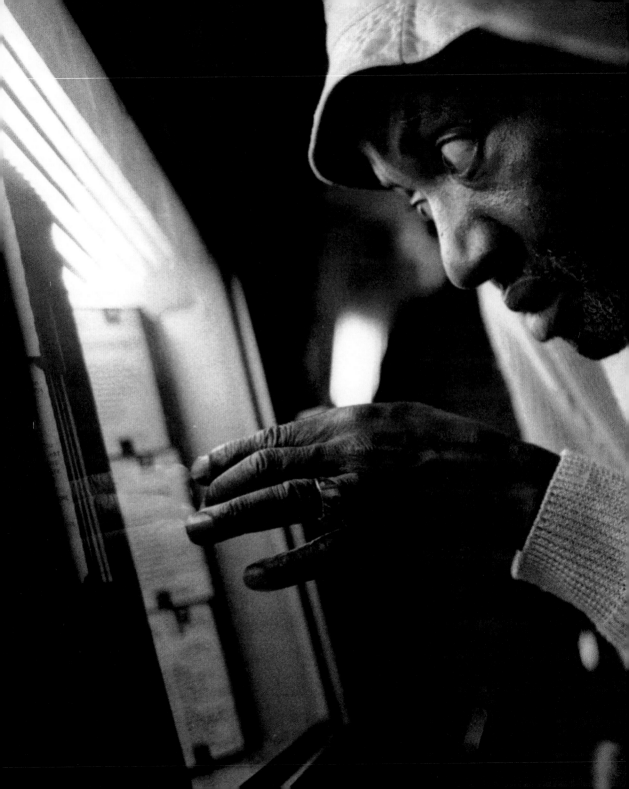

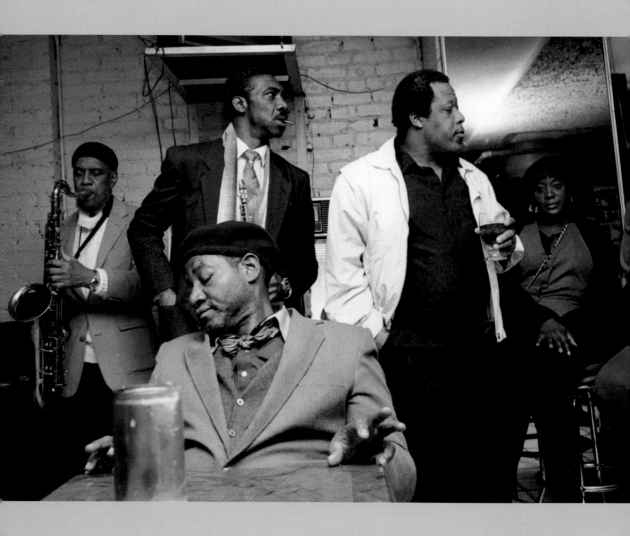

some musicians no work

some musicians tell me "there's no work /

out there" least ways not for the music

they play / joe rasul & david are all in

paris / but i can find some black bands

where we live / play in bebop blues & r&b /

sure you gotta look / gotta go where folks

aint so well off / but you can find some

music that's as colored as it is live /

folks dance / the bop the chicago walk & swing /

they revive black big band sounds with a little

old five piece band sound / in texas & louisiana

zydeco music is the rage / some churches

even have zydeco nights / just like bingo

it's ours and we won't let it go / gives us

a chance / to make us smile at each other /

hold each other / show what we can do with

all the memories we have of etta james

ellington count basie & the moonglows

maybe even the flamingos / there's music out there fellas

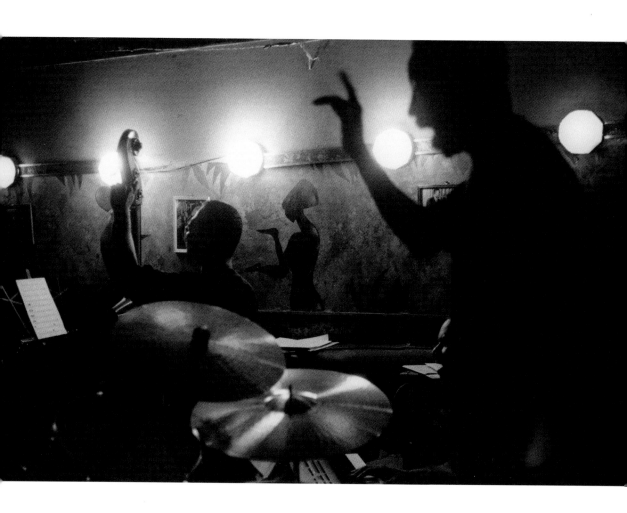

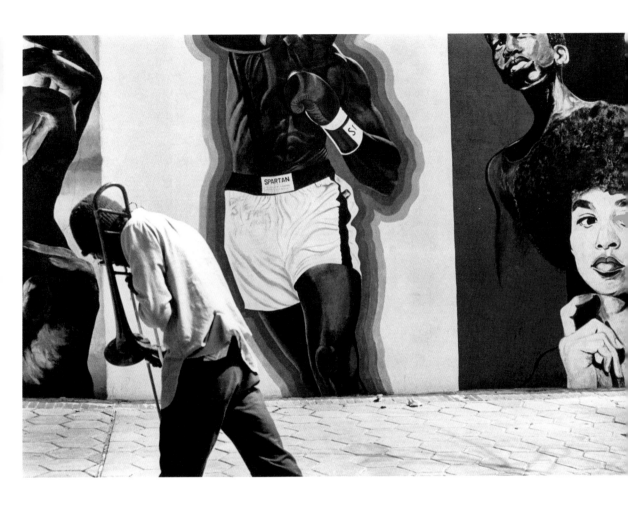

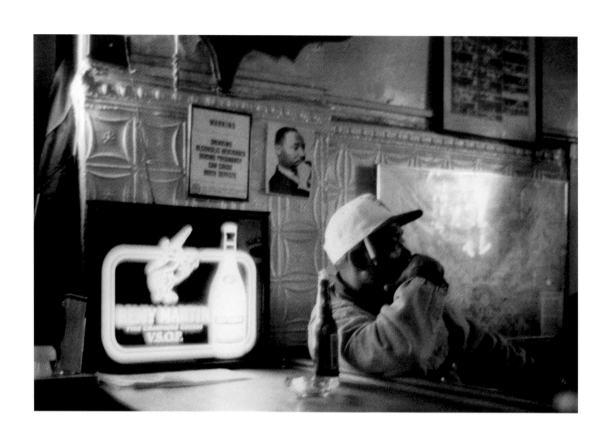

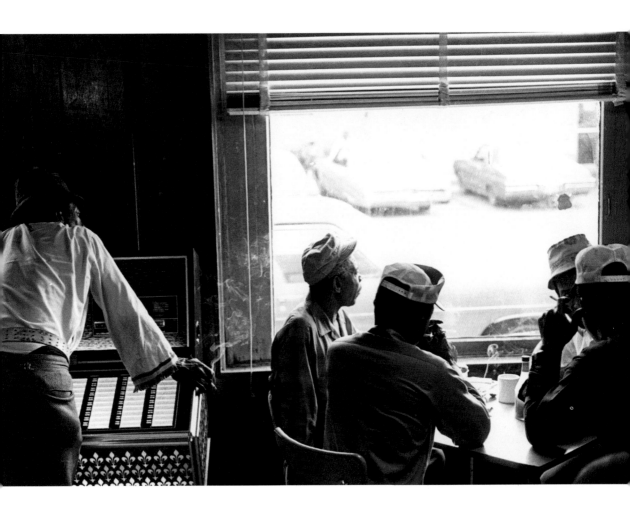

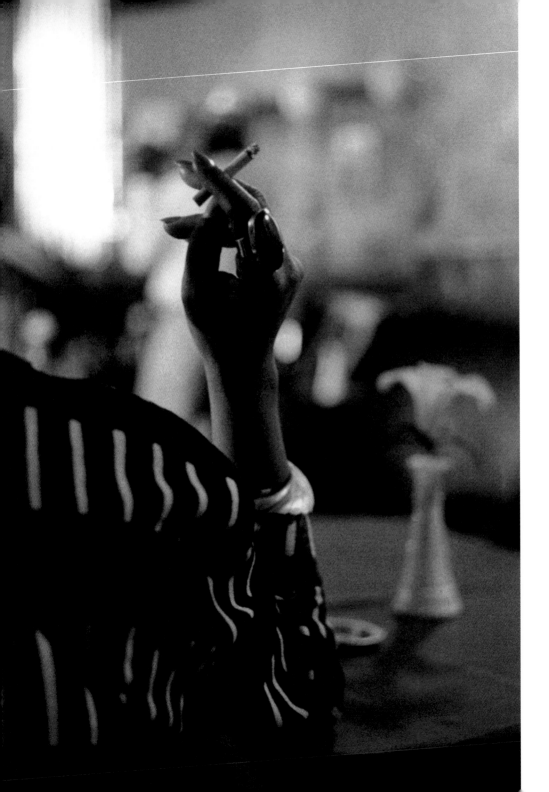

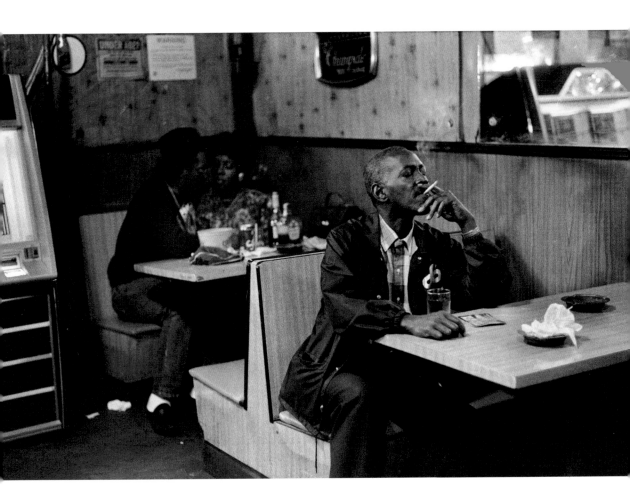

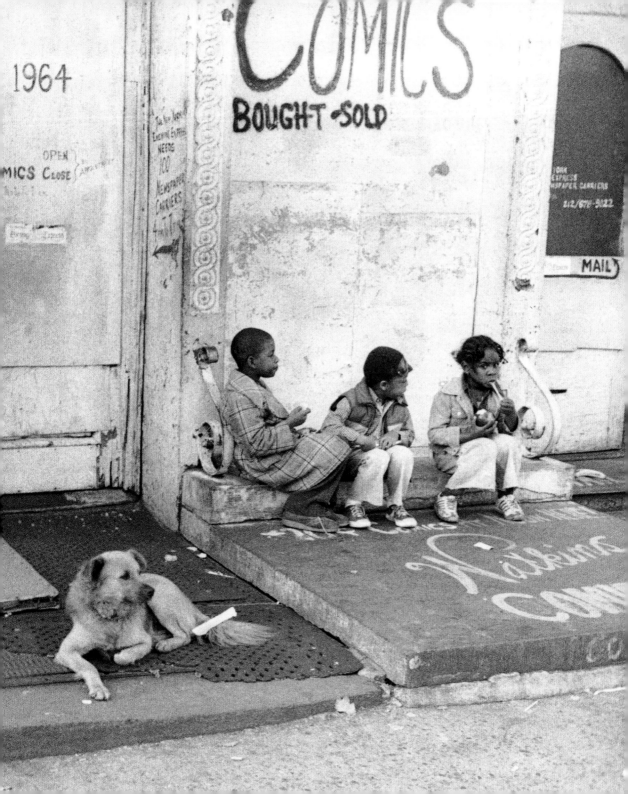

Lawd have mercy it's the truth

we must have more churches

that liquor stores / got churches on top of

the other / talkin bout the Healin Missionary

church / C.M.E. churches are still around /

A.M.E. churches growin / big glamorous

baptist churches / more subdued high episcopal

churches / got churches for recovering drug addicts /

churches that are historic landmarks of

the underground railroad / churches on television

twenty-four hours a day / then there was

Daddy Grace whose mission is still

functioning in philadelphia / & rev. ike

& his mighty prayer cloths / there was a dance

rehearsal studio / on top of rev. ike's

pulpit / i was training in ghanaian dance / that's

how come i know / there always been churches

with some singin & band / now they got dancers some of

them do / they even gotta blk catholic church /

but that's newly come along / they got black

folks going to white folks sposed to

work miracles / i tell ya we must be

closer to jesus than the disciples

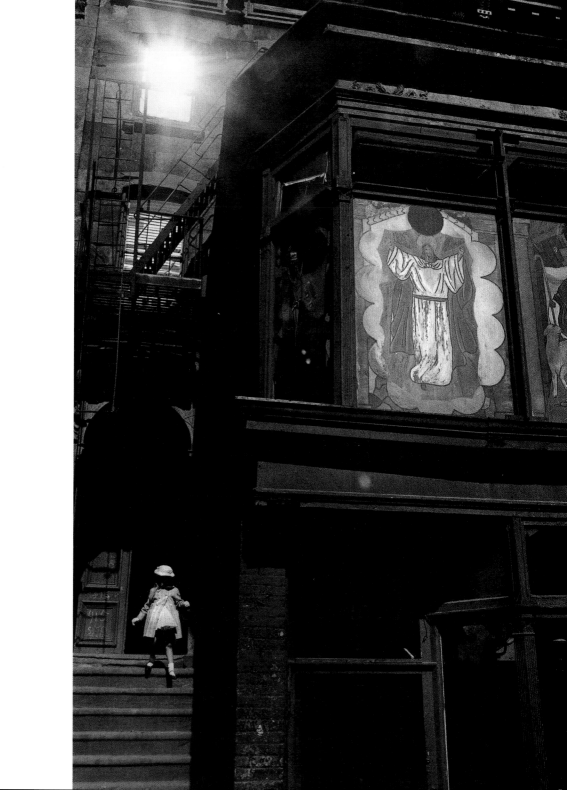

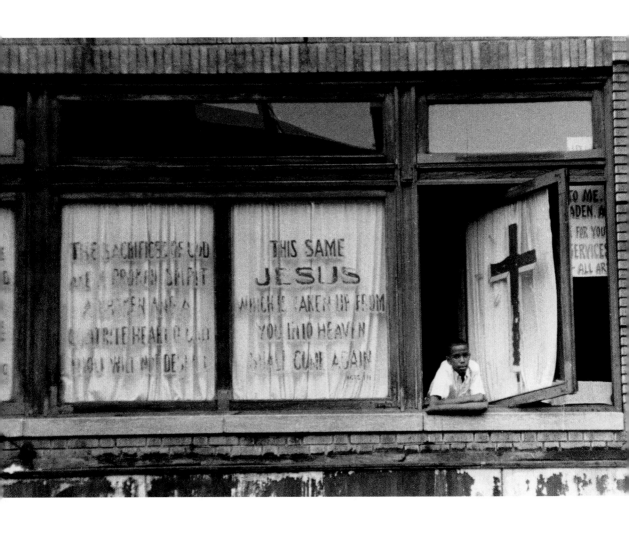

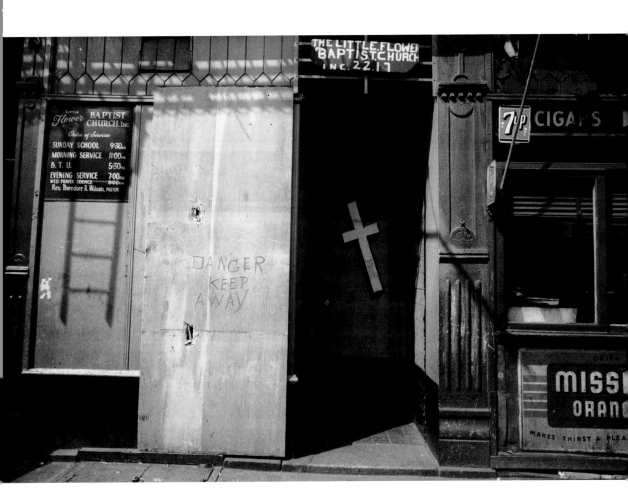

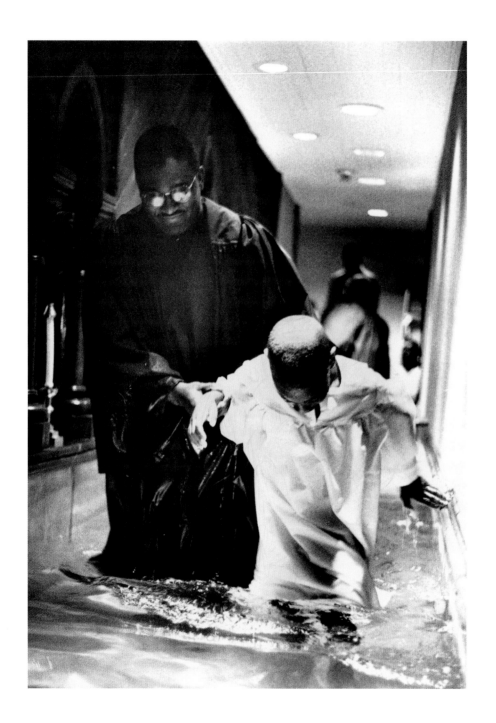

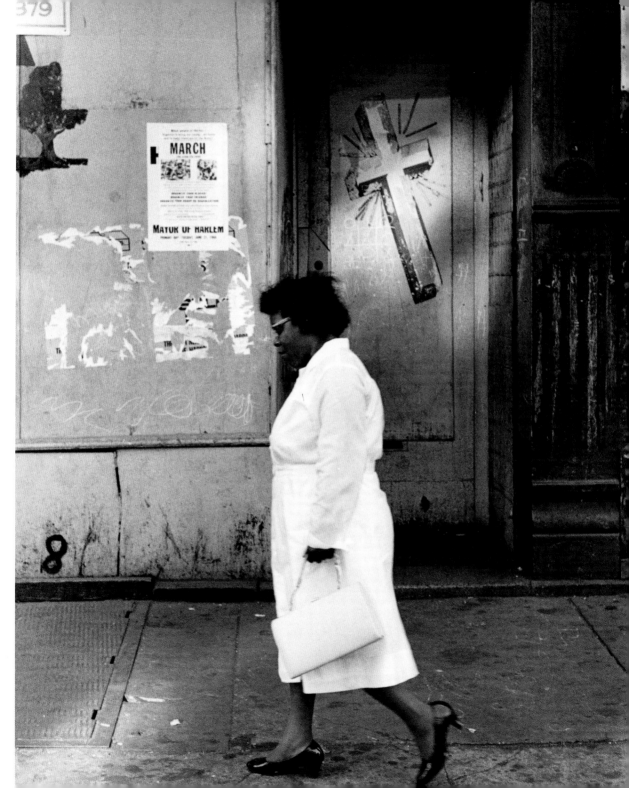

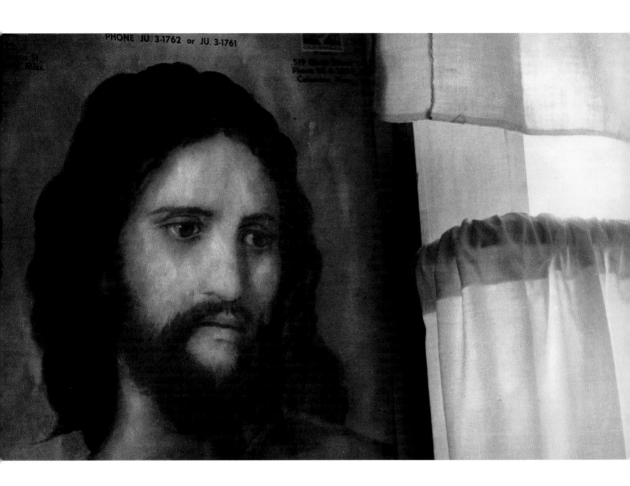

jesus must know

 we are chastened by his love

 jesus must know we

 bathe in his blood

 but who could tell we

 are on the right side of god

 we're hidden in glorious chapeaux of spring the

 King who is Risen

 Recognizes us

who's hair isn't done

let me get in that head honey

the day is lace and crinolines

curls, satins, and layers of beauty

who's mama wouldn't be proud

who's eye won't be turned when

i saunter outta this room where

the magic is and become it

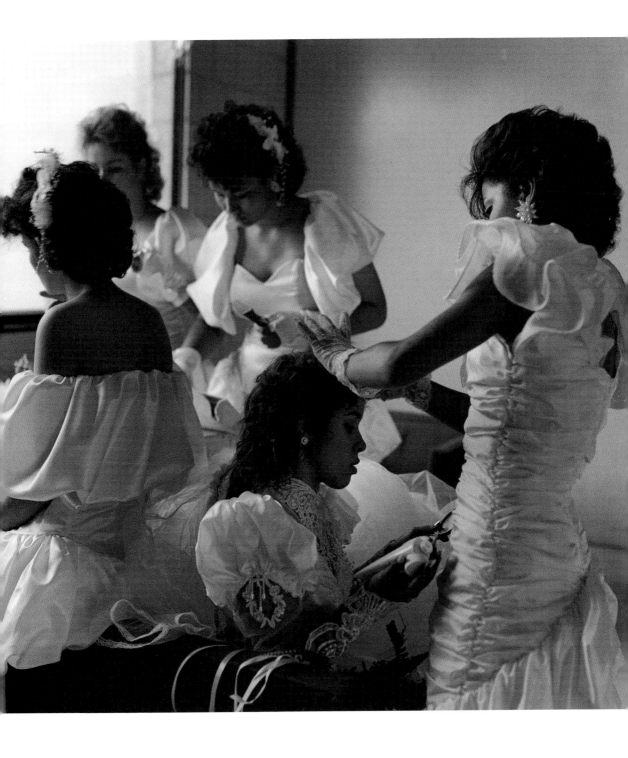

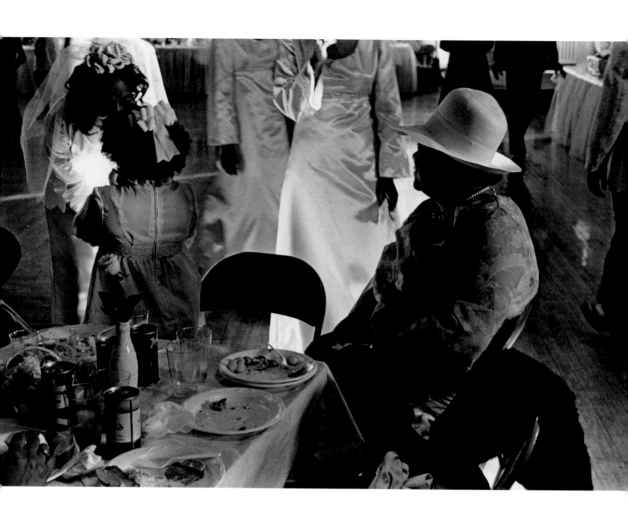

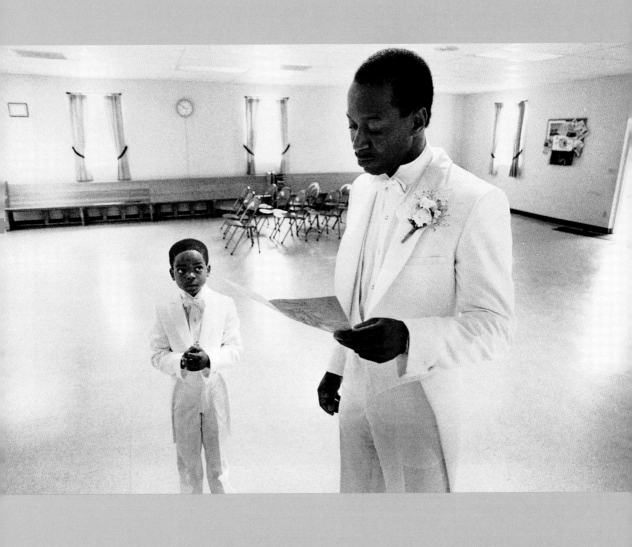

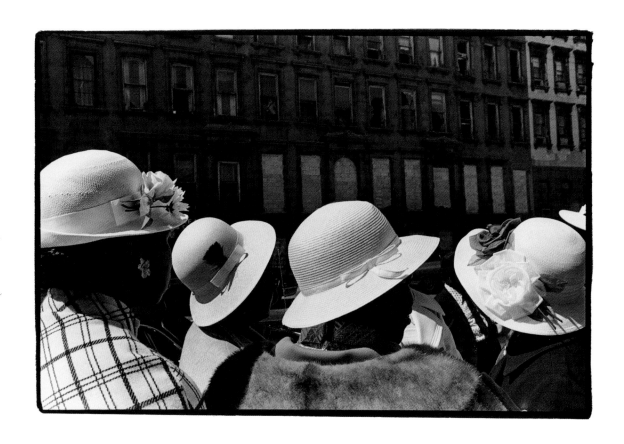

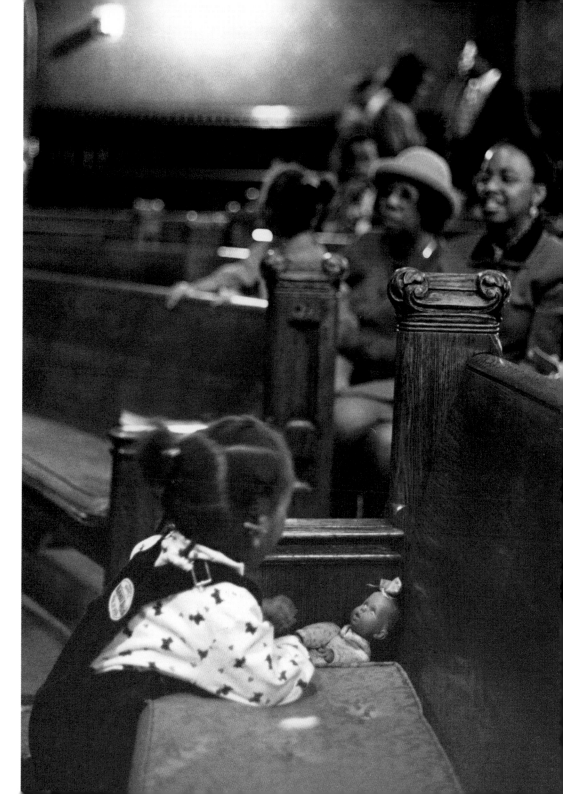

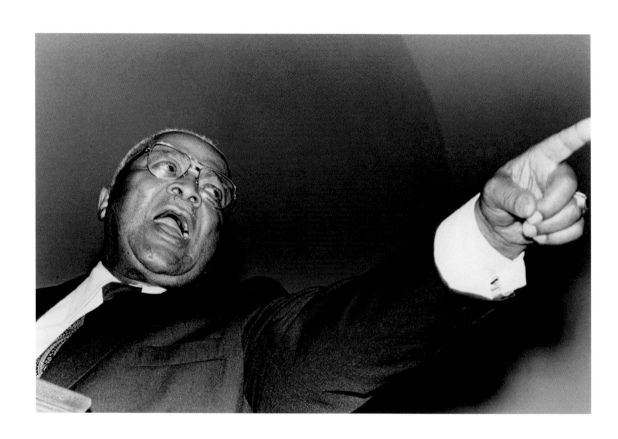

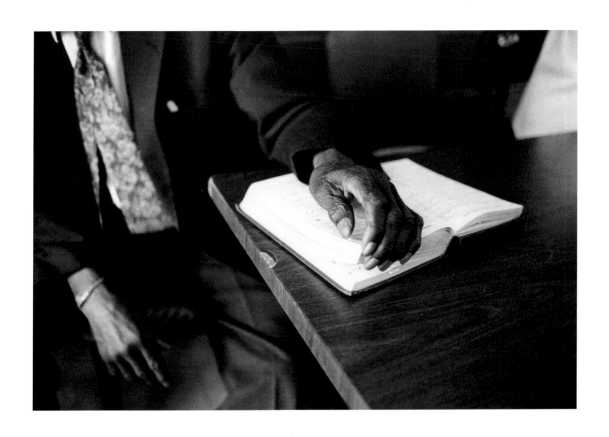

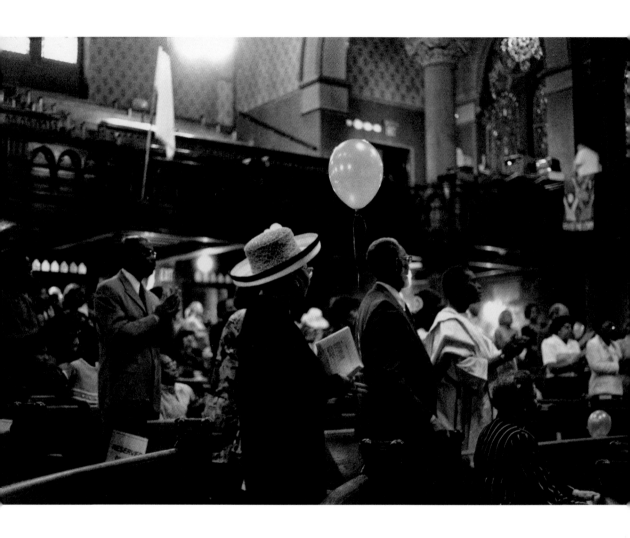

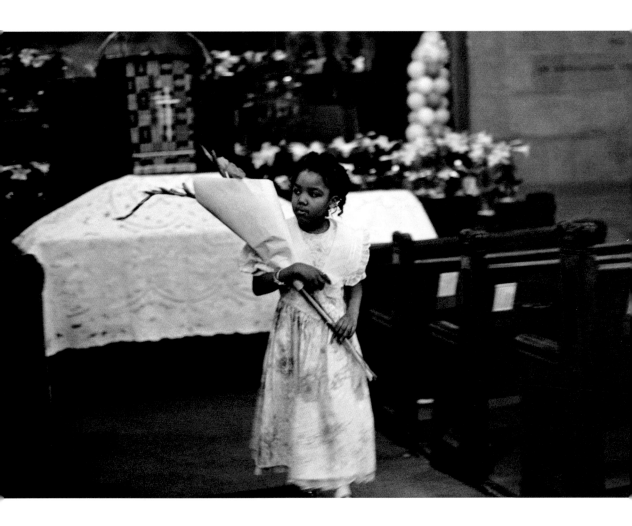

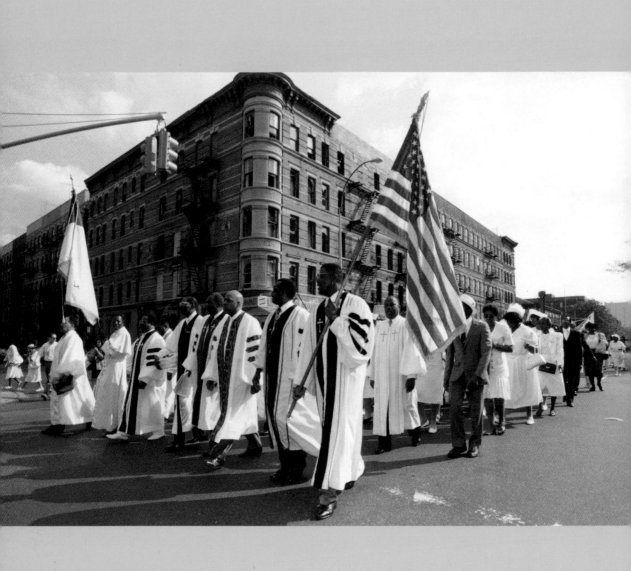

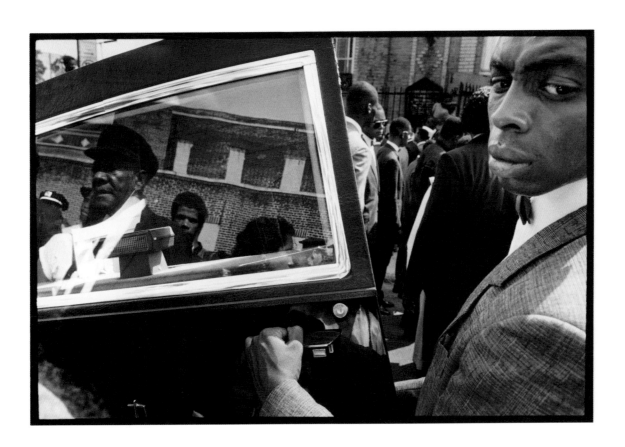

149

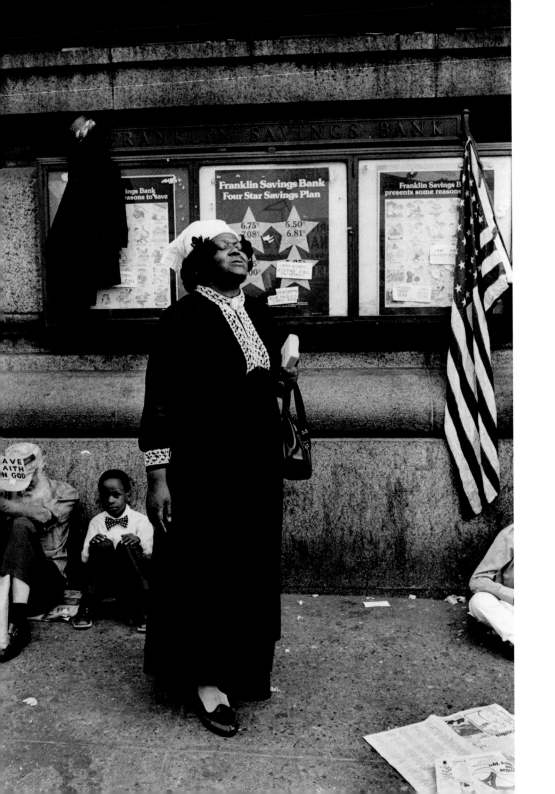

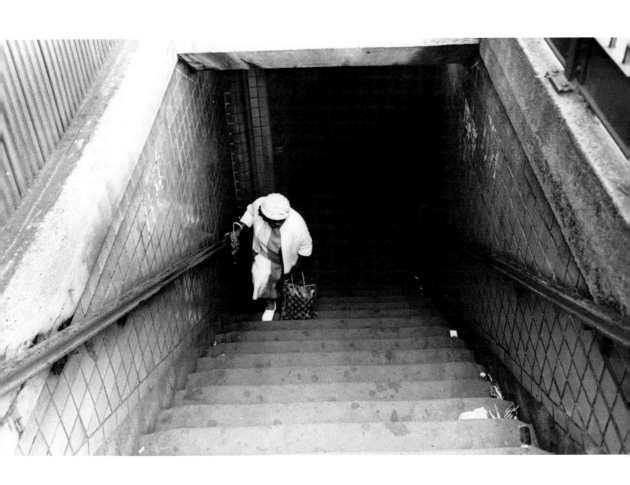

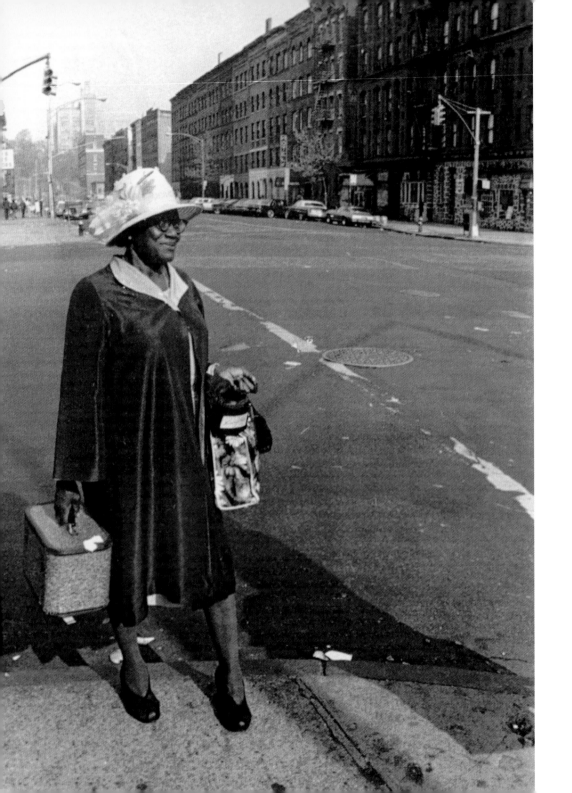

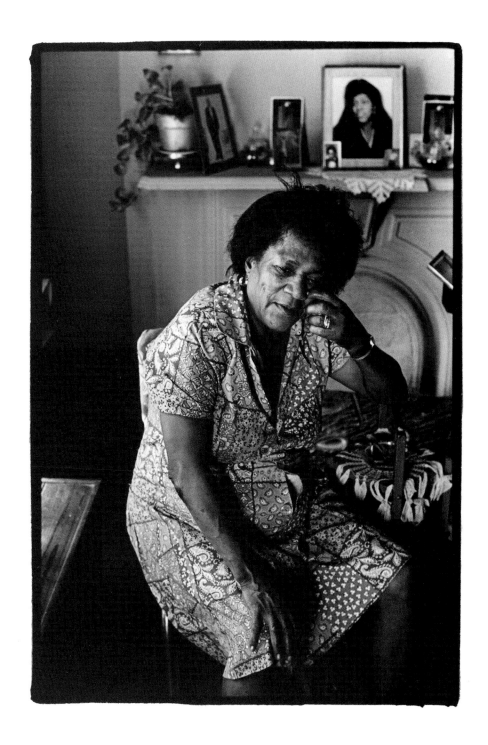

153

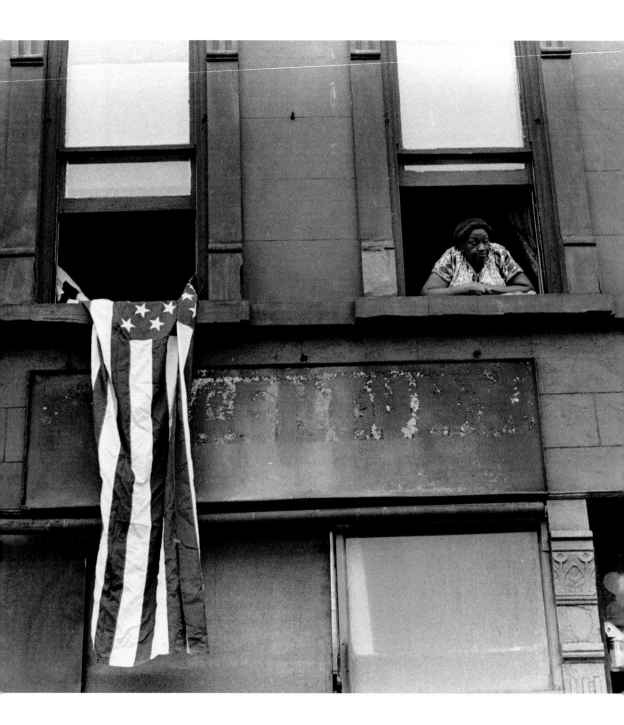

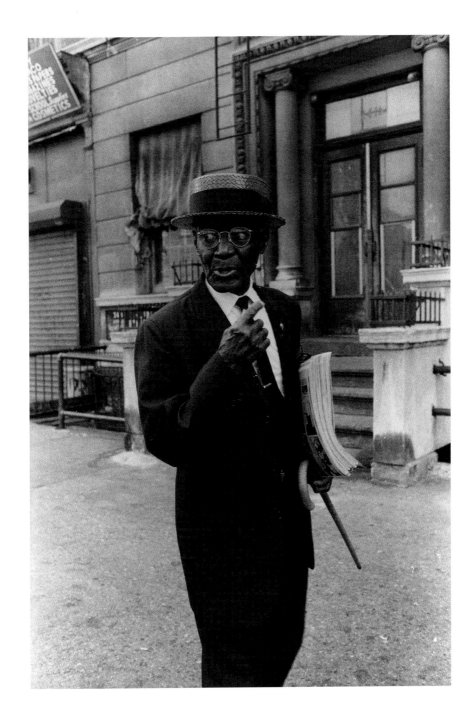

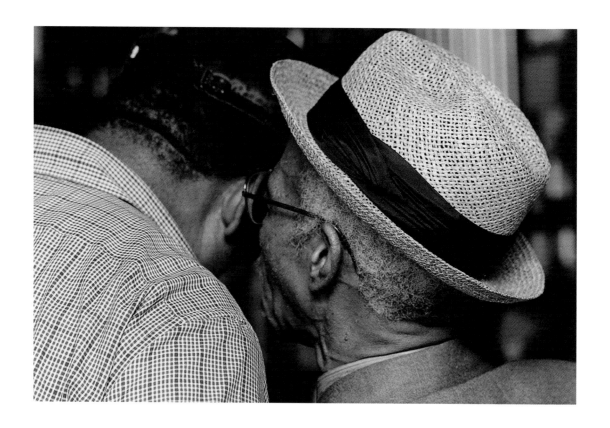

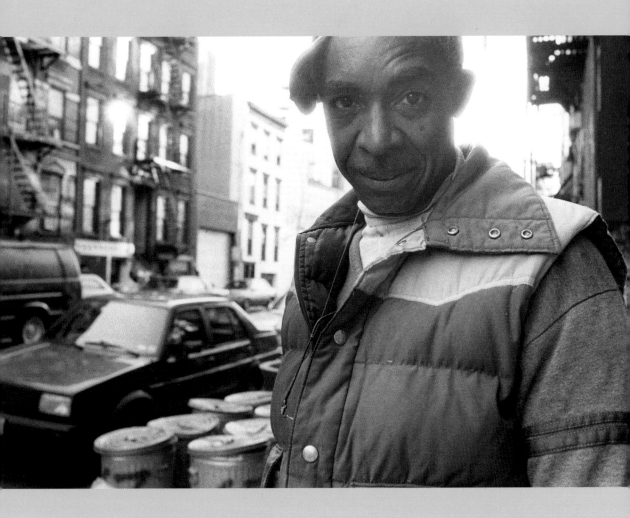

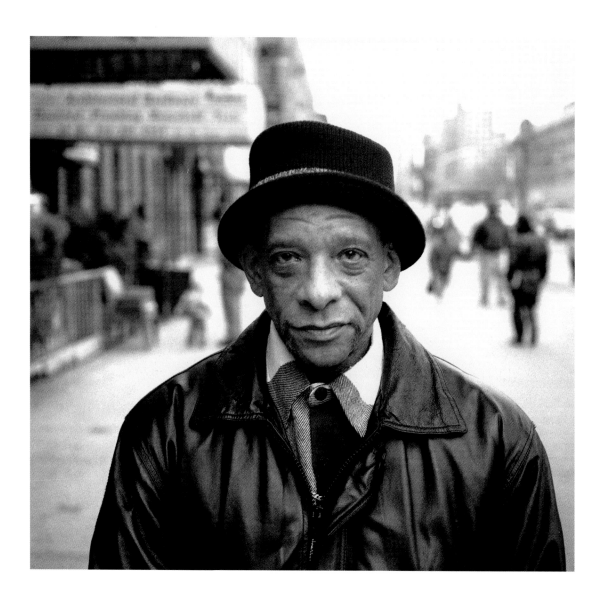

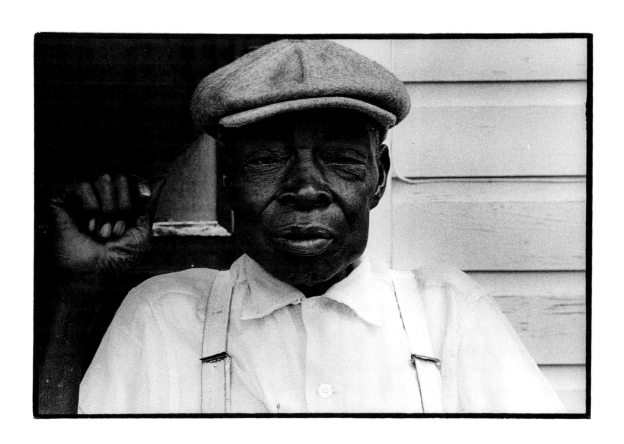

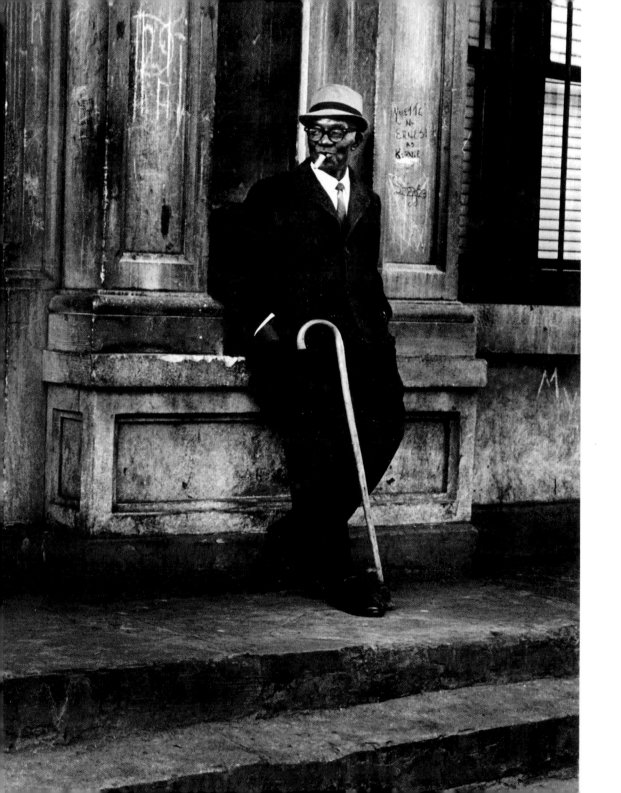

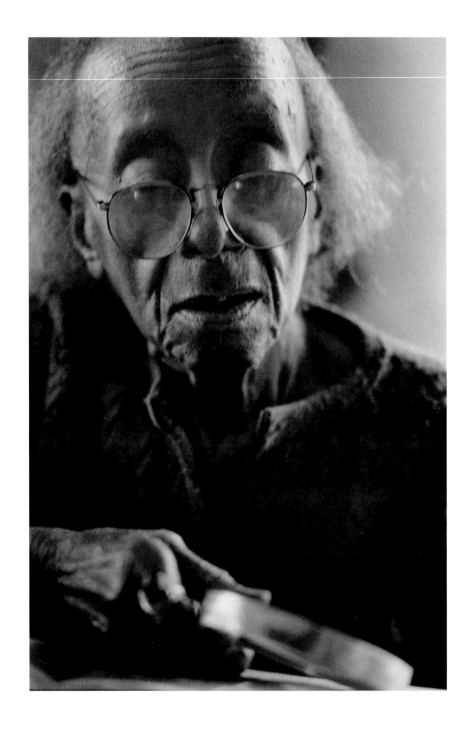

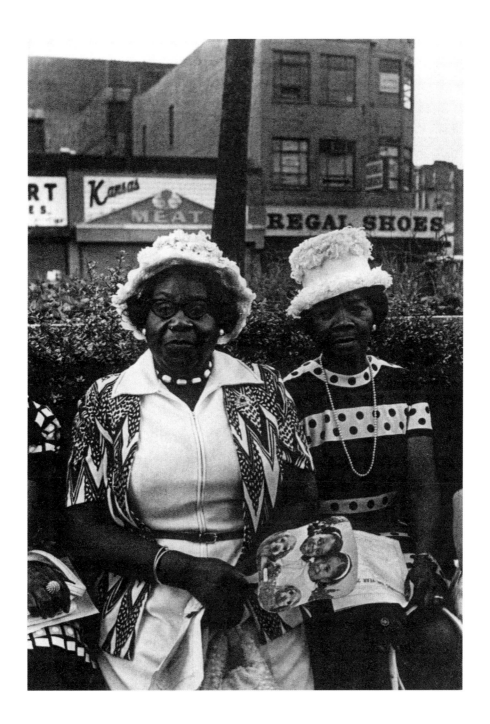

do you remember?

maybe not nana maybe great great aunt mary

doesn't really matter / she's the family

can call up every generation from her soul

she remembers her husband, greer, gettin' called

up for WWII & comin' home limpin' / she's

aware her nephew was called up / korea bound / never

to come home again / her daughters / there were

seven / were more wild than a christian woman

ought to be / but they all went to college or

cosmetology school / some of them widowed now

or divorced / but they doin' well / it's their

children who worried her the most / 2 suicides /

one shot to death by the police in his own

house / two great-grands barren / the others

got too many to care for / one boy in jail for

10 more years / drugs got him / & alcohol almost

all the rest / too many sorrows for one

old lady / but i remember sittin' on her lap

in the rocker / her warm skin & wonderful aroma

that made me safe / i felt love as she rocked

& rocked

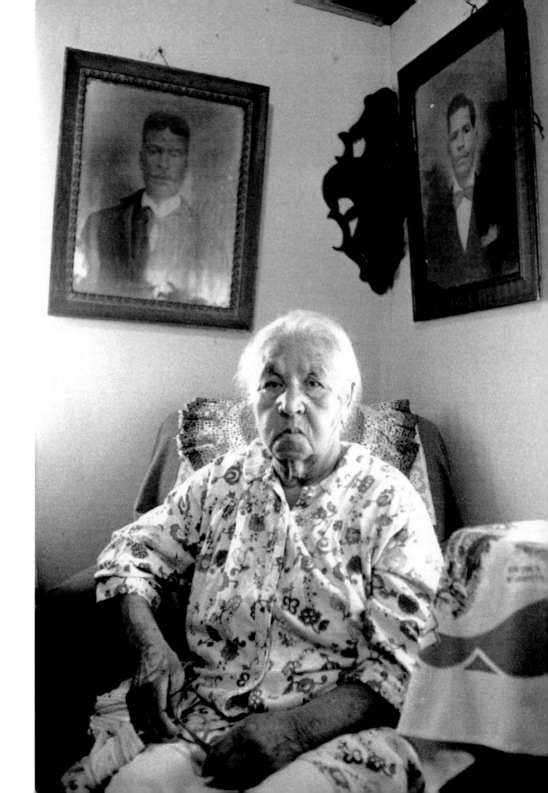

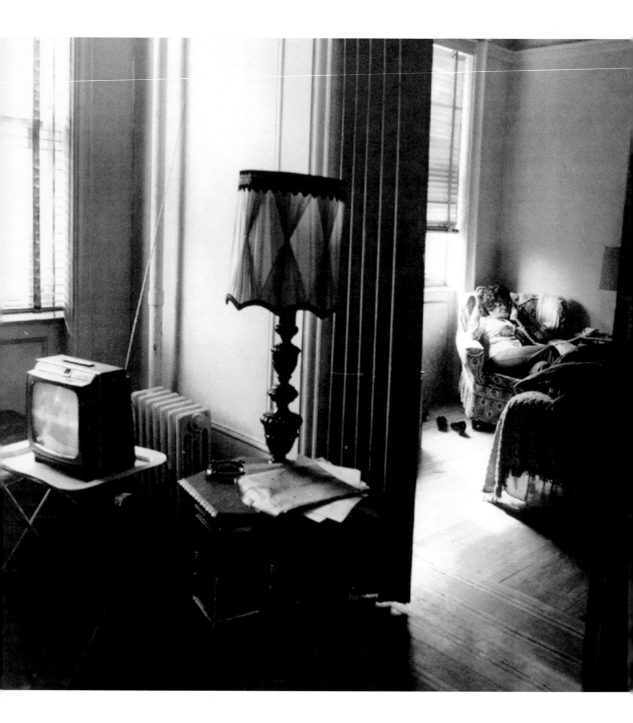

Anthony Barboza is a self-taught photographer with a wide-ranging interest, having excelled in the worlds of documentary, commercial, fashion, editorial and fine-art photography. He was awarded New York State Council on the Arts grants in 1974 and 1976, a National Endowment for the Arts grant in 1980, and a New York Foundation for the Arts grant in 2002.

Adger Cowans received a B.F.A. degree in photography at Ohio University in 1958 and served as a military photographer in the United States Navy. His images have been published in *The New York Times, Harper's Bazaar, Time, Life, Look, Essence, Modern Photography, Paris Match,* and several books, including *Sacred Bond: Black Men and Their Mothers,* 1998.

Gerald Cyrus has a degree from the University of Southern California, an M.F.A. from the School of Visual Arts, New York, is a New York Foundation for the Arts fellow, and an artist-in-residence at Light Work (1995), Syracuse, New York. Gerald is a photographer whose subjects have included African-American families, jazz musicians, New York street life, Southern blues culture, and Brazilian portraits. He has been widely published and exhibited. He lives and works out of Philadelphia, Pennsylvania. He is also a Sacatar Fellow.

Louis Draper (1935–2001), a founding member of Kamoinge, earned an M.F.A. from New York University in film studies in 1970, and a B.A. in Humanities from Thomas Edison College in Trenton, New Jersey, in 1987. He received a New York State Council on the Arts grant in 1973 and a Light Work artist-in-residence in 1995. He was also Kamoinge's secretary, and Professor of Photography at Mercer County Community College, New Jersey.

Albert Fennar, a founding member of Kamoinge, was born in New York City in 1938, and worked as a film/video editor for NBC News. Al learned photography in the late 1950s in Japan while serving a three-year tour of duty for the U.S. Air Force. Returning to the U.S. after being discharged, he went to work at Photo Lab, where he met other photographers; some became original members of the Kamoinge Workshop. Al works in digital photography and currently lives in Long Beach, California.

Collette Fournier, a resident of Rockland County, holds an M.F.A. from the Union Institute and University at Vermont College and a B.S. from R.I.T. Ms. Fournier is an adjunct professor at SUNY Rockland Community College and has worked as a staff photographer for the *Journal News,* the *Bergen Record* and freelanced for the *New York Post.* Her photographs have been shown in galleries throughout the United States, Canada, and Russia.

James Francis, a founding member of Kamoinge, was born in New York City in 1937. On his fifteenth birthday, his cousin bought him a twin-reflex camera, which was his introduction to photography. Ray has taught photography at the Bedford-Stuyvesant Neighborhood Youth Corps, Pratt Institute, and he worked as a senior photographer for the New York City Department of Sanitation. James self-published *Moments* . . . and is currently working in digital photography.

Steve Martin (1945–2003) studied photography at Austin Community College in Texas. His work has been exhibited at Museum of the City, Countee Cullen Library, the Schomburg Center for Research in Black Culture, UFA Gallery, and other venues. He curated several photography exhibitions and taught at Houston-Tillison College. His photographs are in public and private collections.

Toni Parks was raised in White Plains, New York. Parks attended the Boston Music Conservatory. She studied photography with her father Gordon Parks, and Adger Cowans. Her photographs have been widely published, exhibited, and collected. Toni lives in Devon, England.

Herbert Randall is a founding member of Kamoinge and has held positions as supervisor, coordinator, instructor, and consultant in photography. His work has been exhibited at the Brooklyn Museum of Art, UFA Gallery, Parris Art Museum and others. Randall is a John Hay Whitney fellow and recipient of other awards. His photographs are in the collections of the Museum of Modern Art, the Metropolitan Museum of Art, private collections, and he is coauthor of the book *Faces of Freedom Summer.*

Eli Reed was born in New Jersey. He is a Harvard University Nieman fellow who won numerous awards for his work, including awards from the Overseas Press Club, World Press, Nikon World Understanding, Mark Twain Associated Press, the Leica Medal of Excellence, the Kodak World Image Award for Fine Art Photography, and the W. Eugene Smith Grant in Documentary Photography. Reed, a member of Magnum since 1983, has covered a large number of editorial assignments for many high-profile clients, and worked on many feature films with directors such as Robert Altman, John Singleton, Marc Foster, and Ron Howard. Eli has produced two books, *Black America* (1988) and *Beirut, City of Regrets* (1997).

Herb Robinson studied in New York at the Fashion Institute of Technology and the City University of New York. His work is in the collections of the Museum of Modern Art and the Schomburg Center for Research in Black Culture, both in New York City, and has been exhibited at the Harvard University School of Design (Cambridge); the International Center of Photography; UFA Gallery; and the Brooklyn Museum of Art. He was commissioned to photograph the reconstruction of "Sue," the world's largest and most famous Tyrannosaurus Rex fossil, now residing at the Field Museum in Chicago, capturing the essential character and teamwork of an exceptional group of artisans and scientist. Robinson's body of work covers a vast range of subject matter and style, ranging from abstract to representational; vivid color to black and white; and traditional to digital. Robinson is also the treasurer of Kamoinge.

Beuford Smith was born in Cincinnati, Ohio. He is a freelance art/photojournalist, president of Kamoinge (1997–2003), founder of Cesaire Photo Agency, and cofounder of the *Black Photographer's Annual*. Smith has taught photography at Cooper Union, the Brooklyn Museum, and Hunter College. Smith was a New York Foundation of the Arts recipient in 1990 and 2000, an Aaron Siskind Foundation recipient in 1998, and a Light Work artist-in-resident 1999. Smith's work is widely published, exhibited, and collected, and he is currently organizing his archives and preparing a book of his photographs.

Ming Smith was born in Detroit, Michigan, and grew up in Columbus, Ohio. The Smithsonian Museum, Museum of Modern Art, Studio Museum, African-American Museum of Philadelphia, African-American Museum of Los Angeles, the Schomburg Center for Research in Black Culture, Watts Tower, and Rush Arts are among her affiliations.

June Truesdale began her career as a photographer after graduating from Fordham University with a B.A. degree in studio art/photography. She has worked as a movie-set still photographer, onsite architectural photographer, freelance photojournalist, staff photographer for *Encore* magazine, and as a New York City Police photographer covering special events, community affairs, and criminal justice systems work.

Budd Williams was born in Harlem in 1949, and is a graduate of the School of Visual Arts, New York. He has worked as an art director in the publishing and advertising fields and as a staff photojournalist at the *Daily News*. His work has been published in *The New York Times, Life, U.S. News & World Report*, and the *Final Call*.

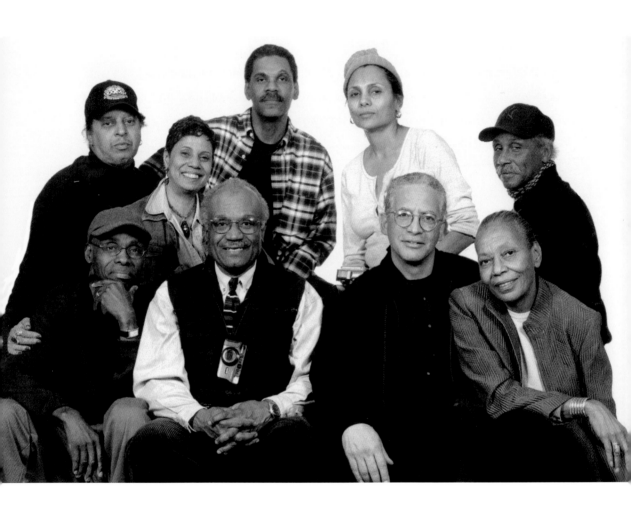

Clockwise from top left: Tony Barboza; June Truesdale; Gerald Cyrus; Ming Smith Murray; Adger Cowans; Toni Parks; Frank Stewart; Beuford Smith; and Herb Robinson. Members not included in group photograph: Daniel C. Dawson; Albert Fennar; Collette Fournier; James R. Francis; Herbert Randall; Eli Reed; Bud Williams. Photograph by Barboza Studio.

List of Illustrations

Born in Nashville, Tennessee, **Frank Stewart** grew up in Memphis and Chicago. He attended the School of the Art Institute of Chicago and studied photography at the Cooper Union, receiving a B.F.A. in 1975. He was vice president of Kamoinge 1997–2003. He is presently senior staff photographer for Jazz at Lincoln Center.

Ntozake Shange, poet, novelist, playwright, and performer, wrote the Broadway-produced and Obie Award–winning *For Colored Girls Who Have Considered Suicide/When the Rainbow Is Enuf.* She has also written numerous works of fiction, including *Sassafras, Cypress and Indigo, Betsy Brown,* and *Liliane.*